D1221353

The graphic reproduction and photography
of works of art

The graphic reproduction
and photography
of works of art

JOHN LEWIS and EDWIN SMITH

W. S. COWELL LTD: London

Distributed by Faber and Faber: London

TR
657
.L47
1969

© John Lewis and Edwin Smith, 1969
First published in London by W. S. Cowell Ltd
and distributed by Faber and Faber
Printed by W. S. Cowell Ltd Ipswich, England
SBN 571 09034 6

s.h.
8/83

circ.
R.W.

Contents and list of illustrations

Contents and list of illustrations

Contents and list of illustrations

NOTE
The photographs of both two- and three-dimensional subjects have all been taken by Edwin Smith, unless otherwise stated in the caption. Any photographs or reproductions of works of art, which have no acknowledgment belong to the authors, except for the two water-colours from William Savage's book, which were loaned by Mr Ruari McLean.

Introduction

The reproduction of paintings and other works of art has exercised the ingenuity of printers at least since the eighteenth century. The earliest efforts of the mezzotinters to reproduce the works of such artists as Sir Joshua Reynolds were often not only successful as reproductions, but as works of art in themselves. No one would quarrel with the opinion that John Raphael Smith's mezzotint of the Reynolds painting on page 19 is not every bit as much a work of art as the Reynolds painting opposite; or that Alken's etching of Rowlandson's drawing on page 23 is not just as sensitive as the artist's original. This sensitivity was an essential feature in reproductive etching, engraving and later lithography. Even when the process camera came into use, men trained as interpretive engravers or lithographers continued to apply their considerable knowledge to correcting, adjusting, even re-drawing or re-etching the work of the camera. Inevitably, such reproduction work was slow and often involved a very great number of printings.

Masking, and vastly improved inks and more receptive papers have reduced this labour so that by any of the major printing processes, it is possible to reproduce most subjects adequately in four printings. Electronic scanners have speeded up the work considerably. But there is still the rub – for the modern graphic reproduction or works of art, the scanner operator and the cameraman, as well as the re-touchers and the proofers still have to have something of that sensitivity that their predecessors the mezzotinters, aquatinters and chromolithographers had to have. Which is no bad thing.

A word about the actual reproductions in this book. At first glance, some may appear good, others less so. All graphic reproduction involves compromise of colour, tone, scale and even process. Without doubt, the Reynolds oil painting on page 18 would have been more effective if printed on a coated paper and by letterpress, but the mezzotint opposite would have been that much less effective on a shiny art paper. For the sake of comparison they both had to be printed on the same paper and the oil painting suffered. Or the Callcott watercolour drawing on page 17 would have been more faithful to the original if the tone of sea and sky had been printed in a grey-green ink rather than in black ink. But this would have involved an additional printing, and would not have helped to have made the point of the caption any clearer. (This was to show that by modern methods and two printings one can achieve a comparable result to the original five printings.)

As for the photography of sculpture and all the other three-dimensional works

of art, unless the cameraman is an artist, he had better take up some other occupation. Edwin Smith, writing on the need to deal sensitively when photographing such things as architectural detail and sculpture says: 'A great part of the magic of church monuments, however, is the total ambience of setting and given lighting. To intrude more than the minimum apparatus is not only to unsettle a mood and to dispel a magic but often to create more problems than can be solved.' Here, apart from the importance of fine lenses and fast films, everything depends on the eye of the man. A glance at Edwin Smith's photographs of the Marble Statue of a Child with Doll (page 119), or the Figures on Tombs in Tong and Charlecote churches (pages 120–1) or the Horse's head from the Elgin Marbles (page 114) should indicate more clearly than any words what this sensitivity means.

This book does not set out to be a technical treatise, but we hope that such technical information that it gives will be useful. Also, we hope that some of our suggestions may inspire a more adventurous attitude both to photographing works of art and to the use of colour in graphic reproduction. J.L.

I The ethos, the ethics and the objectives of graphic reproduction

Ethos Characteristic spirit of community, people or system
Ethics Treating of moral questions, rules of conduct

A painting is a painting, whatever the media used or the material on which it is painted. A coloured reproduction of a painting, is not a painting. It is something quite different; the fact that it may be given an embossed, paint-like surface, put in a frame and hung on a wall, does not alter the case one jot – and the nearer it comes to the original, in some ways, the more objectionable it becomes – for if there is any danger of it being *mistaken* for the original, it becomes a cheat.

This does not mean that a printer should not attempt to get as near to an original as possible, for, quite clearly, if a coloured reproduction appears in a book, it cannot be the original painting. What one has to decide, however, is the primary purpose of the reproduction.

In the case of a book about the work of a painter such as Turner, are the reproductions meant to be a vivid introduction to the artist's work, so that anyone seeing *for the first time* a reproduction of *Snowstorm: Steam-boat off a harbour's mouth*, would rush to the National Gallery to see the actual painting; or are the reproductions mere visual reminders – such as the postcards art galleries sell, which of course, are greatly scaled down approximations of the originals; or are they details such as colour or tonal notes? These are all valid uses of colour reproduction. The last one – the detail – is a particularly valuable one. But there are problems to be faced. Problems not only of accurate colour representation, but of tone, texture, lighting and the resultant shines and shadows from what may be a three-dimensional surface. And more important than all this, there is change of scale. By large reduction, the values can change – so that if one sees a postcard-size reproduction of a large painting, before one has actually seen the work of art, the original may be almost unrecognizable – particularly if it is a non-figurative painting. It may be a fearful disappointment as well.

THE CASE FOR MONOCHROME REPRODUCTION

In works of critical scholarship and in catalogues, there is a real case for keeping to monochromatic reproduction. With careful photography one can at least control the tonal contrasts. Certainly for small scale reproduction, a crisper result can be obtained from a single plate, than from the overprinting of four half-tone plates. Though the larger the reproduction, the less noticeable is this lack of sharpness.

The distinguished English painter, John Piper, writing nearly twenty years ago, said: '. . . when a painter's work is reproduced in colour, by whatever method,

he should ask for a lively parallel to his work, not an imitation of it, in colour or in any other particular.' The artist goes on to say: 'He should ask, in fact for the same kind of result he would get if he translated a work of his own into another medium.'[1]

[1] Penrose Annual No. 43, 1949.

Mr Piper was asking for more than most colour printers would be capable of giving him. It is much more difficult to interpret than to imitate; but if the operatives of reproduction processes bear this interpretation in mind, they might still arrive at more vital results than they normally achieve. Even with the electronic scanning devices, personal control must be exercised in selection. A computer is only as clever as its programmer allows it to be. The operatives of these ingenious devices may have every possible scientific qualification, but unless they have the eye of an artist, their work will be no better than their machines allow.

THE REPRODUCTION PRINTMAKERS

We think that there is something still to be learned from the reproduction printmakers, who were working before photographic methods came into use. One of these pioneers in colour reproduction was William Savage, who was in charge of the printing department at the Royal Institution. Savage had been born in Howden, Yorkshire in 1770 and came to London in 1797, being appointed to the Royal Institution two years later. The job appears to have been a sinecure, and with time on his hands, in 1803 he began a printing business of his own, largely as an excuse for experimenting in colour printing. The medium he used was the wood block and inks based on *balsam captivi* and dried turpentine soap. To bring his experiments before a wider audience, Savage set to work on a book which was advertised in 1814, subscribed, but not finally published *in toto* until 1823. The title of this rather discursive volume was *Practical Hints on Decorative Printing with Illustrations engraved on the wood.* In his introduction he remarks: '. . . printing will not be stationary; men of superior abilities having of late applied themselves to its improvement.' These were prophetic words. Savage's method for colour reproduction was to break down a painting into its component colours and after engraving a key line wood block, he would engrave simple flat shapes for the various tones and colours. Even for the little monochromatic river scene by A. W. Callcott, R.A., on page 17, his engraver, G. W. Bonner, cut a line block and four flat colour blocks, using four pale shades of grey for the clouds, waves and shadows. For a repro-

duction of a watercolour by J. Varley (page 26), the engraver J. Thompson used fourteen blocks. His order of printing foreshadowed modern practice, for he began by printing the clouds in a pale neutral tint and then the light blue sky, using Antwerp blue, then he advanced progressively to the darkest shades. Finally after the darkest parts of the design had been printed, the trees were glazed with a green varnish. Savage used boxwood from the Mediterranean for large blocks and English box for small ones. Savage's prediction that 'printing would not be stationary' was amply fulfilled, for only four years after he had published his book, Nicéphore de Niepce made his fundamental discovery. Modern photo-engraving had its origins in this moment, when Niepce succeeded in producing an engraving by the use of a light-sensitive, albumen-coated plate and so made possible photographic reproduction on raised surfaces, on intaglio and lithographic plates. Less than half a century later, in 1861, Clark Maxwell opened the way for all future methods of colour reproduction by re-iterating Le Blon's theory that any colour can be imitated by a mixture of red, green and blue lights. Until these discoveries were fully exploited at the end of the century by the development of the Levy half-tone screen, all colour reproduction had to be drawn, etched, lithographed, engraved or worked in some way or another by hand.

In the first years of the eighteenth century, a German of French extraction called James Christopher Le Blon had invented a process of colour printing using only three primary colours, a red, blue and yellow. Le Blon's invention was the direct result of Isaac Newton's work on the spectrum, and his theory that the various colours of the spectrum were made up of a limited number of primary colours. Newton thought that there were seven primaries, but by the time Le Blon had started his printing experiments, this number had been reduced to only three. The process Le Blon used for printing was the mezzotint. He had no cameras or colour filters to help him in his work, so had to depend entirely on visual analysis and colour selection. He used a separate plate for each colour. Printing the blue first, the yellow next and the red last. He came to London in 1719 and so successful were some of his plates based on the paintings of Rubens and Van Dijck, that some of them, after being heavily varnished, were sold as originals. Even as captious a critic as Horace Walpole thought Le Blon's plates very tolerable copies.

The methods of mezzotint, aquatint, lithography and wood engraving were used with varying success. Their success was attributable not only to the skill

and dexterity of the craftsmen who drew or engraved the blocks or plates, but also to the powers of selection of these men, and to the critical observations of the artists whose work they were reproducing. Their prints rarely attempted to look, for instance, like an oil painting. They were recognizable translations into an utterly different medium. The success or failure as representations of the original, lay mainly on how well or how badly, for example, the mezzotinter or lithographer had selected the factors that mattered in the original picture.

EDMUND EVANS AND THE COLOUR REPRODUCTION WOOD ENGRAVING

William Savage had worked with flat wood blocks to provide a great number of tints. In the 1850's this expensive process was greatly modified by Edmund Evans, the originator of the 'Yellow Back' novel covers for Routledge's *Railway Library*. Evans describes this method of working these covers in his reminiscences.[2]

'The popular artists of the day were asked to supply drawings which were engraved on the wood; then two "transfers" from the engraved block, i.e. impressions while wet laid face down on the plain blocks, then through the press so that the wet impression was "set off" on the plain blocks, and used, one for a *red* printing, the other for a *blue* printing, the red being engraved in gradation to get the light tints, such as faces, hands, etc. The blue block being engraved to get the best results of texture, patterns or sky, crossing the blue over the red to get good effects of light and shade . . . there were generally three printings used, black, blue and red, or black, green and red: the very most was made of each block by engraving so as to get the best result for the money!'

This economical but vivid result was greatly helped by the bright yellow enamelled paper on which the blocks were printed. The 'Yellow Back' covers were not exactly works of art but much of Evans's work was quite beautiful. Evans had set up his press in Racquet Court, Fleet Street in 1851. His contract for the 'Yellow Back' covers came within a very short time. He also printed a great number of children's books, illustrated by such artists as Walter Crane, Randolph Caldecott and Kate Greenaway. Some of the work of Birket Foster that he printed in colour is both charming and subtle, but his reproductions of Kate Greenaway's drawings are what he is best remembered by. The coloured woodcut on page 27 is from *Little Ann*, published by Frederick Warne & Co. This watercolour drawing has been beautifully printed from wood blocks by

[2] *The reminiscences of Edmund Evans*, edited and introduced by Ruari McLean: Oxford, at the Clarendon Press, 1967.

Edmund Evans in six colours, certainly a much more economical piece of printing than Savage's version of the Varley drawing. The comparison with the original is an indication of Evans's skill.

THE INTAGLIO PROCESSES OF GRAPHIC REPRODUCTION
'The history of line engraving is one of a magnificent original means of expression that rapidly deteriorated into a process of reproduction.'[3] However much we may regret the loss of originality, we can certainly rejoice in the quality of so many fine reproduction engravings, from the portrait engravings of the seventeenth-century French school to the fashion plates of the 1800's. Though they are reproductions, they are creative reproductions and can stand in the manner of an original work. It is hard to achieve this by the mechanical means of today.

[3] *Etching and Engraving* (1953) by John Buckland-Wright. Published by Studio, 1953.

ETCHING
The etching on page 20 is taken from a watercolour by J. M. W. Turner drawn for *An Antiquarian and Picturesque Tour round the Southern Coast of England* published in 1849 by M. A. Nattali. This particular etching was by W. B. Cooke. Apart from the rather mechanical cross-hatching of the sky, it is a spirited piece of interpretation, probably transfer-printed from a lithographic stone, as there is no background tone from the plate. There can be few artists whose works were more difficult to reproduce by means of an engraved or etched line.
Etchings, whether printed from transfers on the lithographic stone, as was the Turner, or by direct printing from the intaglio plates, are difficult subjects for photographic reproduction. If it is possible to use a line negative (as for *The Mew Stone*), the result should be more faithful than using a half-tone screen. Otherwise it means using a very fine screen (200–300-line) and printing by offset, as for the Whistler etching, *The Pool of London*. An alternative is to enlarge the original, so that the very fine lines can be picked up more easily by the camera and put on to the plate from a line positive, to make a valid printing surface.
Etching came into use as a less laborious substitute for line engraving and was widely used during the first half of the nineteenth century as a means of reproduction. Artists such as Rowlandson, Gilray, Alken and Cruikshank used it for illustration and printmaking. These prints were usually hand coloured, often

in garish colours and painted by unskilled and even child labour. It was penny plain, twopence coloured stuff.

The Stare-Case (opposite) is Rowlandson's conception of what the approach to a *Soirée* at the Royal Academy was like when it was still under the roof of Somerset House. This print was etched by Rowlandson from a drawing he did about 1800.[4] The colouring of this copy (in the British Museum) is fairly slap-dash. The reproduction has been done by the Jemsby Process and printed in trichromatic colours by offset. The Jemsby Process holds the line and the detail better than the normal methods of contacting film used in offset reproduction.

MEZZOTINT

Prince Rupert introduced the art of mezzotint from Holland into England at the Restoration. It became so widely used here as to be known abroad as '*La manière anglaise*'. It was used for every kind of graphic reproduction, but for portraits more than anything else. The works of Van Dyck, Lely, Kneller and later, Sir Joshua Reynolds, were reproduced by this medium. One of the greatest exponents of this art was John Raphael Smith, who engraved in colour, the work of, amongst others, Reynolds, Morland and Romney. Mezzotint, though 'a long-winded and difficult technique was at its best, better than any photographic process, for it was an interpretation of a creative work by an artist–craftsman'.[5] Mezzotint is certainly an arduous process. The reproduction is made by scraping away a prepared ground. This ground is laid by means of a rocking tool, which has a semi-circular blade about three inches wide, deeply engraved on one side with lines, which make up the cutting teeth when the reverse side of the tool is bevelled. The tool is rocked from side to side across a smooth copper plate, making little dents in the copper and throwing up corresponding burrs. When the plate is covered with these burrs, it is ready for the artist to start scraping away his design. If he inks the plate up before scraping, he will get a print of a velvety blackness. Where the artist leaves the burr, he gets a black printing, where he scrapes it away to the original surface, he gets a light grey, with the indentations holding some ink; for a white, he has to

[4] Joseph Grego, writing in his *Rowlandson the Caricaturist* (1880), goes to some pains to apologize for what he terms 'the artist's license'! In his reproduction of the print, Grego covers the ladies' bare bottoms with voluminous knickers!

[5] John Buckland-Wright: *Etching and Engraving*. Studio, 1953.

Opposite to page 16.
Exhibition Stare-Case: a hand-coloured etching by Thomas Rowlandson (15¾″ × 10⅝″) 1811. Reproduced from a coloured transparency by the Jemsby process and printed by offset lithography from line and 150-line screen half-tone plates.
By courtesy of the Trustees of the British Museum.

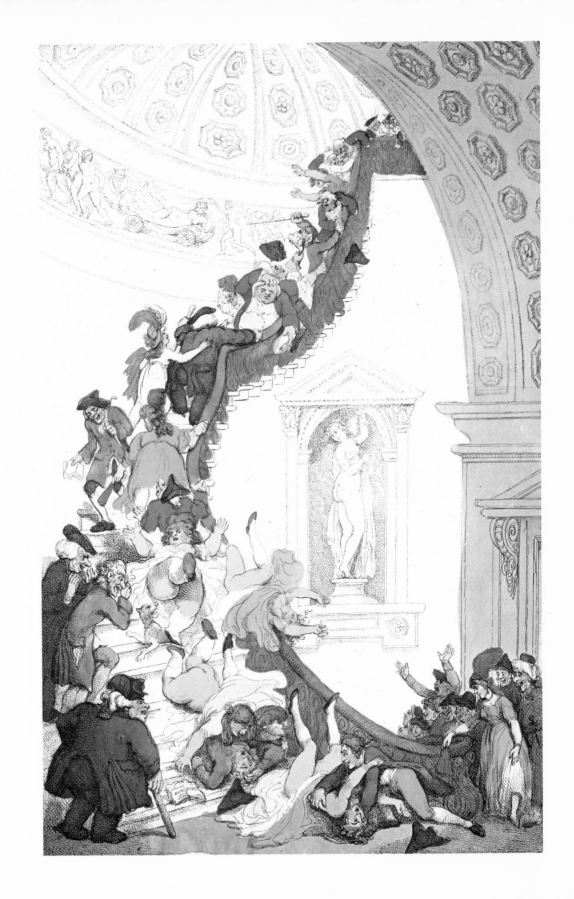

River Scene by A. W. Callcott R.A. Engraved by G. W. Bonner from a pen and wash drawing
(5″ × 8″). This coloured wood engraving was printed from five wood blocks; one for the line
and four for the sky, water and shadows. It appeared in *Practical Hints on Decorative Printing* by
William Savage, 1822 (see page 12).
Reproduced and printed by offset lithography in sepia line and black half-tone from 150-line
screen plates.

[6] Gerald Philip Robinson: *The Encyclopedia Britannica* (13th Edition).

obliterate the indentations altogether.[6] The printing was done from one plate,
which was rolled-up in a ground tint, usually brown and then hand-coloured
either by a stump brush or *à la poupée* (a rolled-up piece of rag). This was
laborious work which had to be repeated for each print. Great care was needed
to blend one colour into another and no two prints were quite the same.

John Raphael Smith's coloured mezzotint, *A Snake in the Grass*, after the painting
by Sir Joshua Reynolds is an attractive representation. The painting is in some
need of cleaning, and no doubt was much lighter in tone when the mezzotint
was made. The reproduction on page 18 of the painting is by normal four-colour
offset, the mezzotint because of its fine detail is by the Jemsby process.

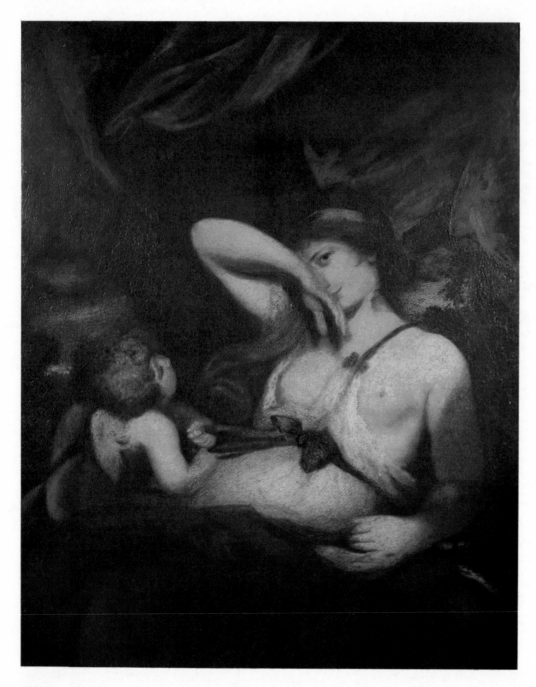

A Snake in the Grass: oil painting by Sir Joshua Reynolds (49″ × 39″). Reproduced from a colour transparency and printed by offset lithography in four colours from 150-line screen plates. By courtesy of the Trustees of the Tate Gallery, London,

Opposite:
A Snake in the Grass: a mezzotint by John Raphael Smith (20″ × 14″) after the oil painting by Sir Joshua Reynolds, published in 1787. Reproduced from a 10″ × 8″ colour transparency and printed by offset lithography in five colours from 150-line screen plates.
By courtesy of P. and D. Colnaghi.

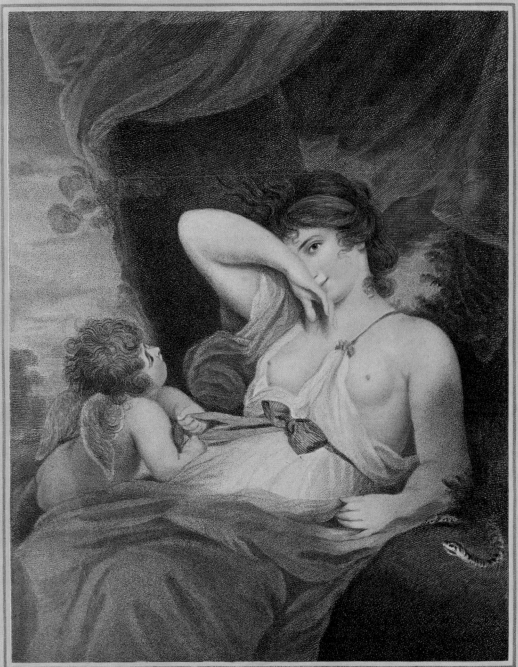

Painted by Sir Joshua Reynolds

Engrav'd by J.R. Smith

A SNAKE in the GRASS.

Fann'd by the summers gentlest wind,
Within the shade a Nymph reclin'd,
As on her neck they artless stray'd,
The Zephyrs with her tresses play'd,
A vest regardless around her thrown
Was girded with an azure zone,
Her figure shone replete with grace,
She seem'd the goddess of the place,
The soothing murmur of the rill,
The plumed warblers softest trill,
The perfum'd air, the flowery ground,

Spread a delicious languor round,
Her swelling breast new tremors move
And all her melting soul was love.
Cupid saw her yielding charms,
And flew insidious to her arms,
The little God she warmly prest;
And ruin in his form carest.
For by insidious harder grown,

He slily loos'd her guardian zone,
Virtue saw the sleight, and sigh'd,
Beware, beware, fond nymph she cry'd,
Behold where yonder thorny flower,
Smiling in summers radiant hour,
With outstretch'd wing a painted fly
In thoughtless pleasure flutters nigh,
Nor heedless sees beneath the brake,
The jaws of a devouring snake,
The Nymph look'd up with conscience flush'd
View'd her loose zone askance_and blush'd

R B. Cooper

19

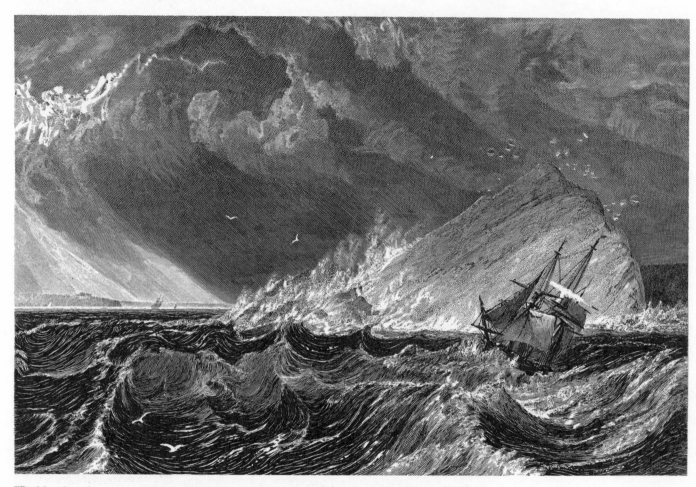

The Mew Stone from a watercolour drawing by J. M. W. Turner R.A. etched by W. B. Cooke
($6\frac{3}{8}'' \times 9\frac{1}{2}''$) from *An Antiquarian and Picturesque Tour round the Southern Coast of England*: 1849.
Reproduced and printed by offset lithography from a line plate. Compare Turner's *Snowstorm:*
Steam-boat off a harbour's mouth on page 58.

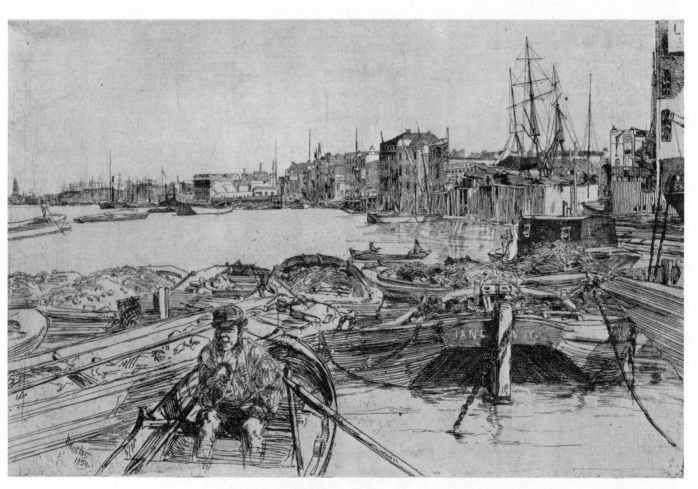

The Pool of London: an etching by James McNeill Whistler ($5\frac{3}{8}'' \times 8\frac{5}{16}''$) published in 1871.
Reproduced by offset lithography from 300-line screen plate.

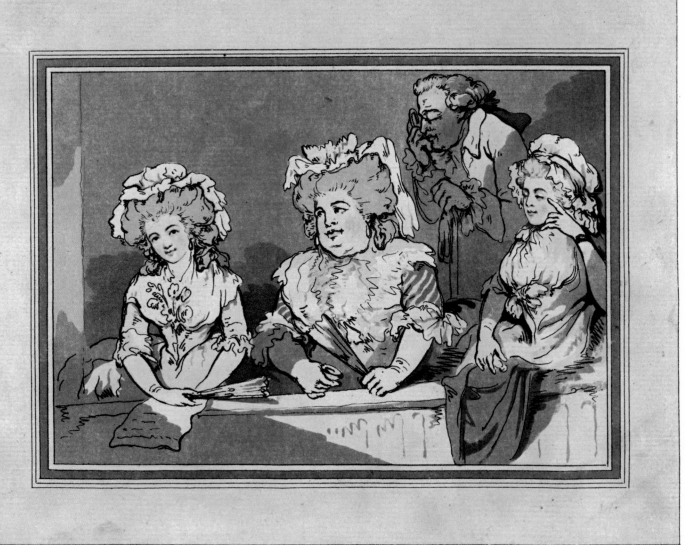

Rowlandson del. *S. Alken fecit*

The Opera Box by Thomas Rowlandson (6″ × 7¾″). Hand-coloured etching, engraved by S. Alken and published *c.* 1785, one of a set of four prints. The grey washes on this print make it look very much like an aquatint. Reproduced and printed by offset lithography in four colours and printed from combined line and 150-line half-tone plates.

Opposite: Baxter print.
The Lovers' Letter-box after a painting by Jessie M'Leod. Engraved and printed by George Baxter and published by him on 30 August 1856 (15″ × 10⅞″) see page 25. Reproduced and printed by offset lithography in four colours from 150-line screen plates.

AQUATINT

The aquatint process, invented in France, was introduced into England in 1775 by Paul Sandby. The process is tonal, the tone being obtained by repeated etchings over a porous ground. It was widely used between its discovery and the mid-nineteenth century for reproduction. It was an admirable medium for representing watercolour drawings. Thomas Rowlandson used the process for his finer work, particularly that published by R. Ackermann. His method was to etch a line drawing, take a proof and put in the tones with washes of Indian ink.

23

Ackermann's engraver would then convert the plate into an aquatint. A proof would be taken and Rowlandson would colour this with delicate tints of water-colour to provide the master copy for Mr Ackermann's young ladies to copy, by the dozen or even by the hundred, to make up the edition. The volumes of *The Travels of Dr Syntax* were illustrated, and the illustrations reproduced, in this manner. It was a much less laborious method than mezzotint or even stipple engraving.

The latter process had been introduced into England by a certain unfortunate called William Ryland, who was later hanged at Tyburn for forging a bank-note. Before this fate overtook him, he had taught the technique of stipple engraving to a young Italian called Bartolozzi, whose success was immediate. For the next thirty years, little annuals and keepsakes were lavishly decorated with Bartolozzi's[7] stipple-engraved nymphs and fauns. The process of stipple engraving was actually a combination of etching and engraving. The stipple dots were made by a needle, through an etching ground. These dots were bitten by acid and deepened with a burin. The first use of the process was to represent crayon drawings, for which it was very effective. Later it was widely used for colour printing, the colouring being done in the same manner as for colour mezzotinting.

As used for Rowlandson's prints or for William Daniel's illustrations to his *Voyage Round Great Britain*, the process of aquatint is a lovely one, with a limpid softness that modern screen processes find great difficulty in emulating. The use today of hand colouring is still possible for short run work or limited editions. A fairly recent example of this was an edition of *Henry Esmond*, illustrated by Edward Ardizzone for The Limited Editions Club of New York, and hand-coloured by Miss Maud Johnson of Oxford.

By the middle of the nineteenth century, the intaglio print as a method of reproduction for bookwork was fighting a losing battle against letterpress and lithography. As long as the speed of letterpress was limited to that of the hand press, the intaglio reproduction stood a chance. With the fast steam-driven cylinder presses, the intaglio print became a luxury.

For colour reproduction, the wood engraving and the chromolithograph had it all their own way, and continued to dominate the field until the perfection of modern photographic colour half-tone work.

[7] Francis Bartolozzi was born in 1725 in Florence. He came to London in 1764 and within four years was made a Royal Academician as well as engraver to the King, George III.

BAXTER PRINTS

The most resolute attempt to produce really colourful reproductions of works of art was made by George Baxter (b. 1804), the son of a Sussex printer and publisher. It is believed that Baxter learned the beginnings of his trade from C. Hullmandel, who taught him lithography, and from Samuel Williams from whom he learned how to engrave on wood. After working with coloured wood engravings, in 1853, he patented his process for the reproduction of paintings in colour. This was an involved process, beginning with a first printing from an intaglio steel or copper plate (on occasions he used a lithographic stone). This first printing was in a neutral grey or *terra cotta* colour and provided, by the dots of mezzotint or stipple, the tones of the picture. On to this tonal base, he would overprint by letterpress from wood or metal relief blocks rarely less than ten printings of oil-based transparent inks. Often he used twenty or even thirty printings. The result was inevitably richly colourful and was really the ultimate in hand-drawn or engraved colour reproduction. The main reason modern process reproduction can, with only four printings, achieve a comparable richness is due to the vastly improved qualities of modern inks and the much greater reflectivity of modern coated papers. When Baxter started work, he found little colour printing being done. Apart from William Savage, who was really an amateur, there was little competition. When Baxter finally retired, he left a flourishing trade, having trained more than one of his rivals, amongst whom were George C. Leighton and Harrison Weir.

REPRODUCTIVE MONOCHROME WOOD ENGRAVINGS

Gleeson White, writing in his book, *English Illustration: The Sixties* (1897) had this to say about reproductive wood engraving versus the process block. 'If anyone doubts that nearly all the drawings of the 'sixties lost much, and that many were wholly ruined by the engraver, he has but to compare them with reproductions by modern processes from a few originals that escaped destruction at the time . . . some few engravers managed to impart a certain interest at the expense of the original work, which not merely atones for the loss *but supplies in its place an intrinsic work of art*.' He continues: 'Given the artist as a craftsman, he may always be trusted to distance his rival, whether it be mechanism or a profit-making corporation . . . for in art still more than in commerce, it is the personal equation that finally controls and shapes the project.' These words still ring true today, and however much subjective judgement is

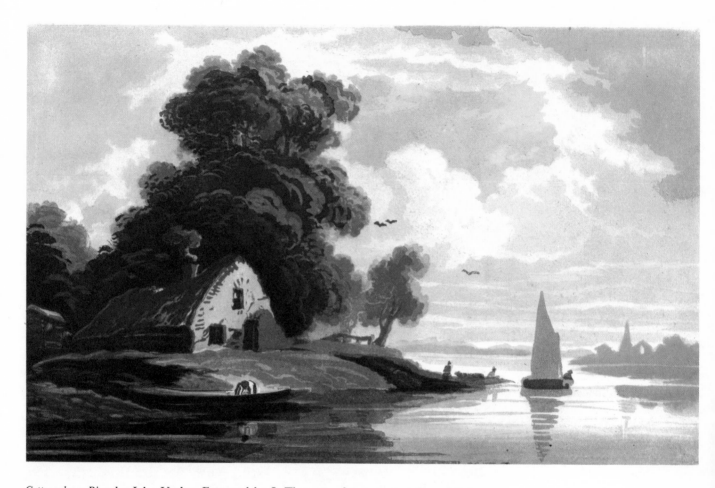

Cottage by a River by John Varley. Engraved by J. Thompson from a watercolour drawing. (5″ × 8″) see page 13. This coloured wood engraving was originally printed from fourteen blocks in William Savage's book. Reproduced and printed here by offset lithography from four 150-line screen plates.

Opposite:
Original watercolour drawing by Kate Greenaway, and coloured wood engraving by Edmund Evans for *Little Ann* published by Frederick Warne and Co Ltd and originally printed in six colours, from designs photographed on to the wood blocks and engraved by Evans.
Both reproduced the same size as the originals and printed in five-colour offset lithography from 150-line screen plates.

FROM THE ORIGINAL WATERCOLOUR

FROM THE COLOURED WOOD ENGRAVING

discounted, ultimately it is the reproduction man's 'eye' that counts.

The woodcut is the oldest method of printing a drawing, and preceded the printing of type (at least in China) by some hundreds of years. The introduction of the engraving of boxwood *across* the grain is a much later innovation and was only brought to perfection at the end of the eighteenth century by the immortal Thomas Bewick, himself trained as an *intaglio* engraver on metals.

Applying the intaglio technique to the woodblock, he produced what have come to be called 'white line' engravings. This method which would seem to be the natural way to engrave a block, was never followed by the interpretive engravers, who slavishly and laboriously retained the *black* lines of a pen or pencil drawing that had been either drawn on the face of the block, or in later years, photographed on to it. One's mind boggles at the fearful labour of digging out all those little rectangles or diamond shapes that went to make up the white spaces in an area of cross-hatching. The artists who drew *for* the wood block, rather than actually *on* the block, rarely played fair with the engraver. They usually used diluted ink with a variety of tones in the lines. As an example, the Charles Keene drawing for *Punch* reproduced on page 50, is in pale sepia ink. It is a lovely drawing which may have faded somewhat in the hundred years since it was done, but the relative tones will not have changed much. No modern process blockmaker could make a line block from this (we have even here had to use a half-tone screen and a sepia printing), but the wood engraver had to do the best he could. In this case, as can be seen on page 51, he did not do too well, in spite of the fact that Keene used little cross-hatching. The engraving is an insensitive production – but this was not always the case.

Where the reproduction engravers often excelled the process engraver, was in the reproduction of wash drawings. The engraved line is a happier match for type than the modern process dot, but there is not much we can do about it today, except to limit the use of half-tone to subjects where this does not matter, or to use a screen that is virtually invisible. The dexterity of the Dalziels' engraving was as well suited to Birket Foster's intricate drawings as it was to the work of the Pre-Raphaelites.

CHROMO-LITHOGRAPHY

The principle of lithography – the antipathy of grease for water – still stands for modern offset, the ink on the roller only taking on the stone or plate where the greasy image appears – for water intervenes elsewhere.[8]

[8] Dry offset, with the use of a relief plastic plate is now used for the printing of tickets etc. It has as yet, no place in the printing of reproductions of works of art.

The inventor of this process – much revered, often mentioned, Alois Senefelder (1771–1834) – sorted out the problems surprisingly swiftly. Within a quarter of a century of the invention, he had most of the answers. The successful introduction into England of the process was due to Rudolph Ackermann, Rowlandson's publisher, who translated Senefelder's treatise on the art in 1818–19. Chromo-lithography is the term applied to *hand-drawn* colour reproduction work on the lithographic stones or plates. One of the essentials of the earliest chromo-lithography, which was called 'Black and Tint work' was the order of printing. The black plate was printed first, just as in the oil paintings of Vermeer or Rembrandt the tonal monochromatic painting with all its nuances of light and dark came first, and the colours followed as *transparent* glazes. This was a sequence that Barnett Freedman, one of the most successful lithographers of this century, was always advocating for lithographic printing. His pleas fell on deaf ears for reasons, at least in part valid, which we will discuss later. In chromo-lithography ten or twelve printings were the norm and often twenty or even thirty were used. The reason for this was the same reason as caused William Savage to use four or five wood blocks to produce a single green-grey colour for sea or sky. The tonal range of a chalked lithographic stone was limited – but the final result of a dozen or so plates overprinting on one another, was often richly satisfying. The intuitive skill of many chromo-lithographers was remarkable. The lithographer would study a painting, decide on, say, twelve printings, and then get down to work, reversing a tracing on to a stone. Copies of this key would be transferred to whatever number of stones were to be used. He would then draw each colour, judging purely by eye how much, or how little chalking was needed. Stipple work, which was much more mechanical than chalking, was very suitable for transferring. It was a process much used on the Continent, particularly in Germany where all those Victorian Valentines and Christmas cards were printed.

The disrepute into which German chromolithography sank was largely due to the 'oleo-lithograph'. This was a lithographed print which was thickly coated with oily varnish and when dry, passed under a heavy embossing roller. The resulting print had a bumped-up surface resembling the texture of canvas or took on the outline of various parts of the design, such as a tree, a figure or a boat. It was certainly an odious variation of what could be an effective process. Grained paper was introduced for monochrome lithographic drawing in 1868. It had little commercial use, but because of its portability it was a boon to artists

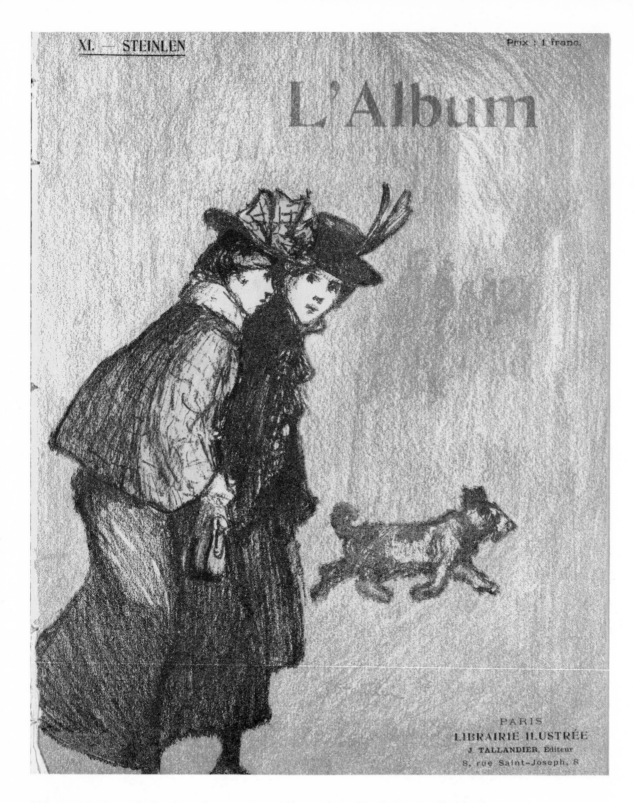

Prix : 1 franc.

L'Album

PARIS
LIBRAIRIE ILUSTRÉE
J. TALLANDIER, Éditeur
8, rue Saint-Joseph, 8

Lithographic Cover Design in yellow, orange, grey and black for *L'Album* by Théophile Alexandre Steinlen. Published by Librairie Illustrée, Paris: 1902 (12″ × 9⅜″). Reproduced and printed by offset lithography in four standard primary colours from 150-line screen plates.

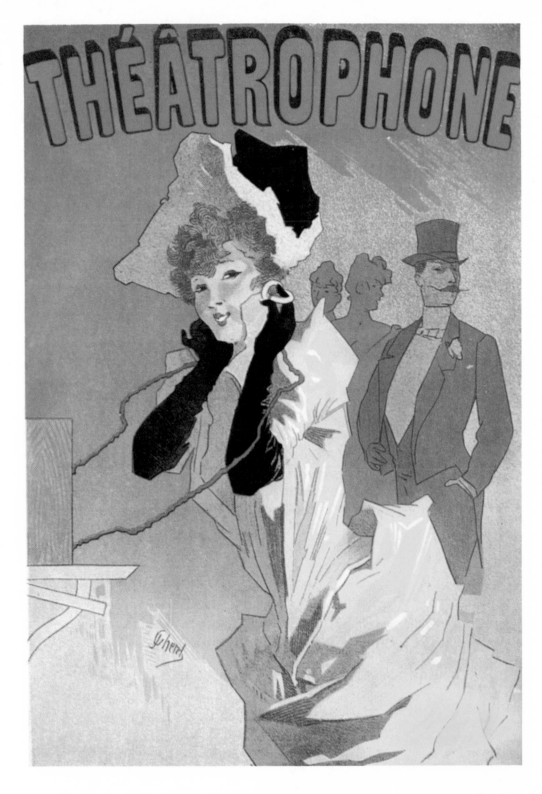

Théâtrophone. Poster lithographed by Jules Chéret in about six printings. The offset litho reproduction, printed in four colours, is from an existing four-colour letterpress reproduction. It has been scanned on a Klischograph which successfully loses the previous screen.

– such as Whistler, Shannon and Joseph Pennell – and what appeared to be a pencil or crayon drawing could be repeated fifty or a hundred times without loss of quality.

CHROMO-LITHOGRAPHY AND THE POSTER

The great achievement of the chromo-lithographers was not the laborious reproduction of paintings, but the production of the posters on the hoardings – the art of the man in the street. One of the first successful uses of paintings for publicity was Millais's painting *Bubbles* used to advertise Pears' Soap. Millais had actually sold the painting to *The Illustrated London News*, who in turn sold it to Pears. The artist knew nothing of this transaction until the Managing Director of Pears proudly showed him a proof. Millais was somewhat put out, but his anger abated when he saw how excellent was the work of the chromo-lithographer. (Including, no doubt, the carefully drawn cake of soap which had been introduced into the foreground.)[9]

The work of the English chromo-lithographers looks somewhat stodgy fare in comparison with that of their French contemporaries, artists such as Jules Chéret, Steinlen, Alphonse Mucha and Henri de Toulouse-Lautrec. R. M. Burch, writing in 1910 says: 'As a method of book illustration, ordinary chromo-lithography is rather in the shade just now, except in France.'[10] Mr Burch then goes on to extol the work of Steinlen. The chromo-lithograph cover to *L'Album*, reproduced on page 30 is by Steinlen, originally drawn on three separate stones by the artist. The French lithographic posters also were often drawn by the artists themselves. Toulouse-Lautrec's work for the hoardings has been reproduced often enough but the reproduction opposite page 80 of his poster *Reine de Joie* is of interest, for here it has been reproduced and printed by silk screen from separations made from a single line photograph. In contrast, the *Théâtrophone* poster on page 31 has been re-reproduced from a four-colour reproduction. This has been scanned on the Klischograph. Jules Chéret, who drew the poster for *Théâtrophone*, was really the first creator of the polychrome poster and was certainly the forerunner of Toulouse-Lautrec in this field. The modern poster is a poor thing compared to these and the days of the chromo-lithographer are over, but it is surprising what a number of men, some still quite young, who, working in the modern offset retouching studios, were trained as chromo-lithographers. What is not so surprising is how much these chromo-lithographers have contributed to the arts of graphic reproduction.

[9] *Graphic Design*, John Lewis and John Brinkley: Routledge and Kegan Paul, 1954.

[10] *Colour printing and colour printers*: R. M. Burch, Sir Isaac Pitman and Sons Ltd, London 1910.

2 Further objectives and purposes of graphic reproduction

Thinking further on the objectives of colour reproduction, one might conveniently divide the types of reproduction into four groups:

1. The reference or catalogue reproduction for students or scholars
2. The gallery postcard
3. The large picture book reproduction
4. The large print

The first group can cover anything from postage-stamp-sized catalogue entries, to large, perhaps actual size, reproductions of pictures or details of pictures. In most cases monochrome reproduction would serve the purposes of this group better than colour, though this may not be so in the case of some detail photographs.

The second group includes not only the gallery postcard, but also similar sized reproductions in relatively inexpensive books. The reproduction at this level nearly always becomes a brighter and more contrasty miniature of the original. Its virtues lie in crispness of register and as much sharpness of detail as can be obtained on such a small scale. It can never be more than an agreeable reminder of the painting.

Letterpress still seems to produce the most pleasant small coloured reproductions, though offset, printed on a coated paper is nearly as good. The softer effects of photogravure or collotype are usually wasted on this scale.

The third group, the reproduction for large art books – the coffee table book – demands the best that the cameraman, platemaker and printmaker can do.

Quite apart from a praiseworthy attempt to make it as like the original as possible, it must also be a pretty thing in its own right, just as John Raphael Smith's mezzotint of a Joshua Reynolds's painting or one of Thomas Rowlandson's own aquatints of his watercolour drawings could stand on its own as a work of art.

The degree of faithfulness for most commercial reproduction is only such as can be obtained from the four-colour printings, using standardized trichromatic inks and printing by letterpress, offset or gravure.

It is remarkable what good results can be obtained, always providing the original separation negatives and/or the coloured transparencies are in their turn faithful to the original. There are still some subjects that need specialized treatment. One could take the extreme case of the work of the Ganymed Press. This press, originally under the guidance of the art critic Julius Meier-Graefe, started in Germany in the 1920's and continued in London after the 1939–45

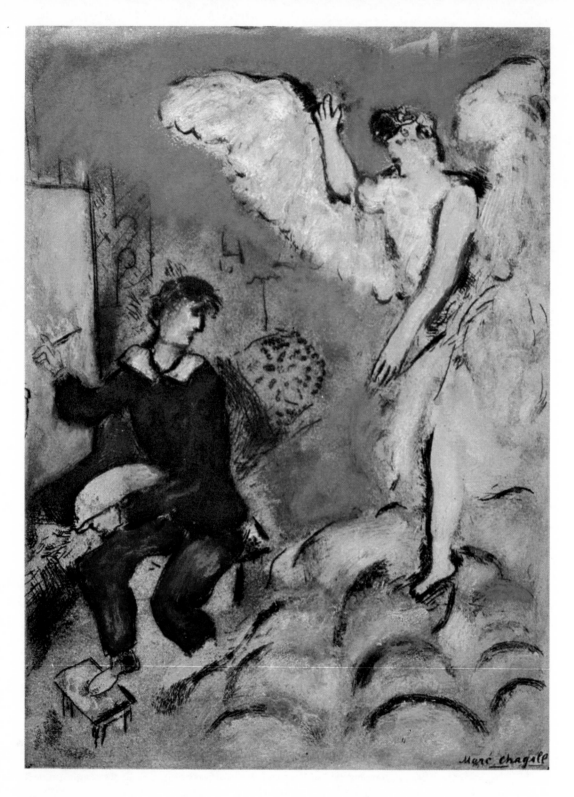

The Vision: Pastel drawing by Marc Chagall ($14\frac{5}{8}'' \times 10\frac{1}{2}''$). Reproduced from a colour transparency and printed by offset lithography in four colours from 150-line screen plates.

By courtesy of the Trustees of the Tate Gallery.

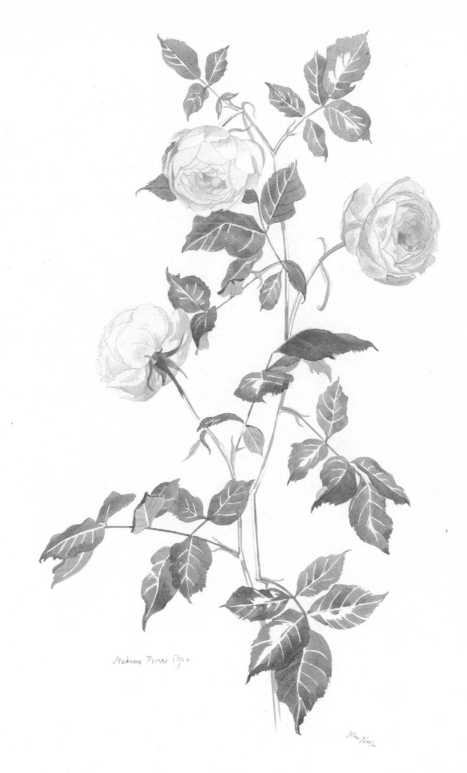

Madame Pierre Oger

John Nash

Madame Pierre Oger: watercolour drawing by John Nash R.A. *c.* 1950 (16″ × 10⅝″). Reproduction from a colour transparency, printed by offset lithography in four colours from 150-line screen plates. This subtle drawing would have benefited by an extra grey printing.

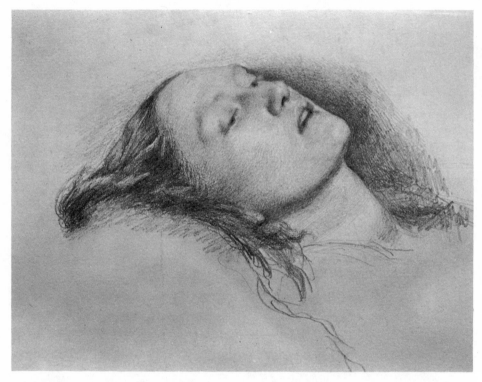

Study for the head of Ophelia (Elizabeth Siddall). Pencil drawing by Sir John Millais (7½″ × 10½″).
Photographed under two 500-watt lamps on Ektachrome 'B'.
Reproduced from the colour transparency and printed by offset lithography from one 150-line screen plate.
By courtesy of the City Museum and Art Gallery, Birmingham.

war. Ganymed used collotype as the basic process, chose only subjects that could be reproduced to the exact size and where these subjects were painted or hand-printed on paper, matched the paper closely. Every reproduction was subjected to the most rigid scrutiny and comparison with the original picture. Collotype with its complete absence of screen was ideal for this very short run, specialized work.

Another example of comparable care in production was the book of King George VI's stamp collection, which Cowells printed in 1952. The method of reproduction used here was for an individual stamp to be photographed through various filters of different colours. Enlarged prints (about 10″ high) were made from these negatives and a line original for each colour printing was made from these by hand work and re-drawing. (At that time there were still a number of artists who had been trained as chromo-lithographers working in the reproduction studios at Ipswich, which was just as well, for this became virtually a chromo-lithographed job.)

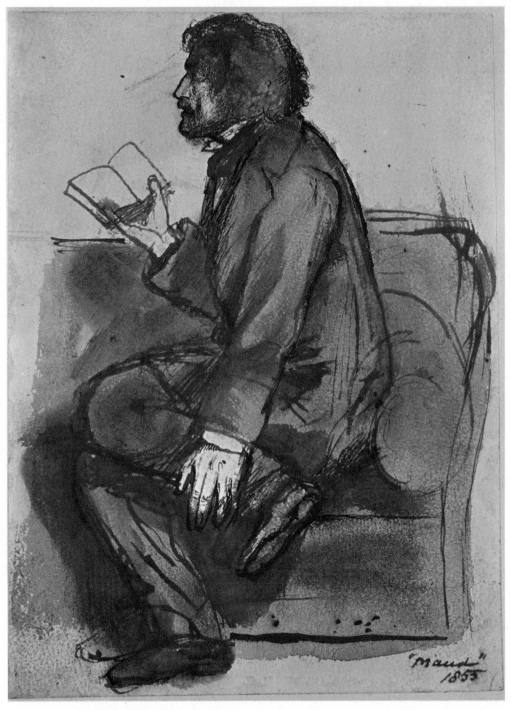

Lord Tennyson reading 'Maud'. 1855. Pen and wash drawing in brown and black ink by Dante Gabriel Rossetti (8¼″ × 6″).
Photographed under two 500-watt lamps on Ektachrome 'B'.
Reproduced from the colour transparency and printed by offset lithography from two 150-line-screen plates.

By courtesy of the City Museum and Art Gallery, Birmingham.

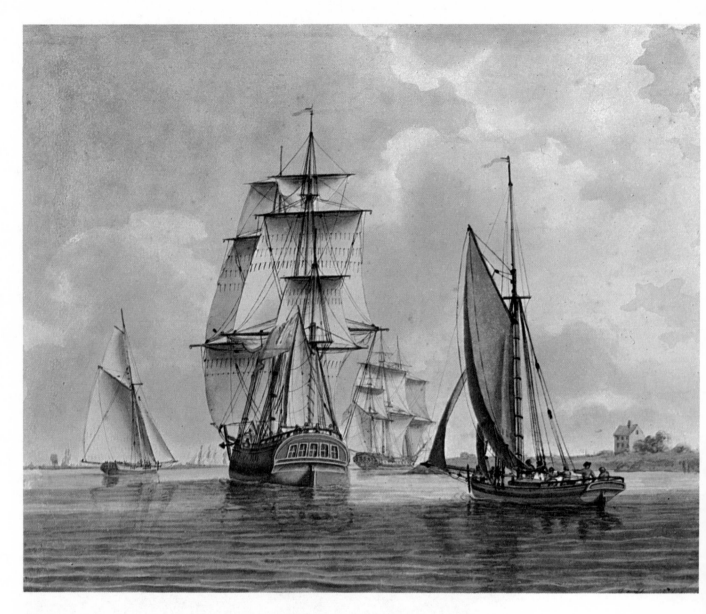

Ships in a calm (*c*. 1805). Water colour drawing by J. Harris (7⅝″ × 9¼″). Reproduced from a colour transparency and printed by offset lithography in four colours from 150-line screen plates.

The reproduction of water colour and gouache paintings

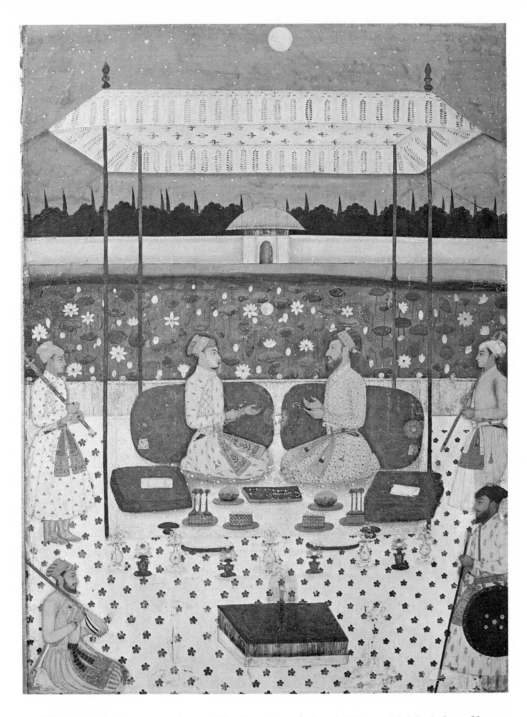

Two Mughal Princes conversing at night. Gouache painting ($13\frac{7}{8}'' \times 10\frac{3}{8}''$) Mughal *c.* 1680–90.
Photographed under two 500-watt lamps on Ektachrome 'B'. Reproduced and printed by
offset lithography from four 150-line screen plates.

By courtesy of the Victoria and Albert Museum.

The large re-touched line subjects were then photographed down to the exact size on the process camera, but without the use of a screen. Using these flat line originals, as many as thirty-five printings were used on a single stamp. Some of the sheets went through the machine fifty-three times. This certainly demanded stable conditions of temperature and humidity as well as very accurate plate-making and machining. It is doubtful whether this laborious method of reproduction will ever be used again. But the result was uniquely successful, mainly because of the absence of any obtrusive screen on these very small subjects.

THE GALLERY POSTCARD

A 133-line screen that is used so commonly in colour reproduction work, is, with good presswork, hardly noticeable in a reproduction twelve inches high. If the reproduction is only a third of that height, the dots begin to jump. As I write this, I have in front of me two postcards, one of them is from the Accademia in Venice. It is of Giorgione's *La Tempesta*. The reproduction is only about four and a quarter inches high and though it is a very fair approximation of the original, when the scale of the figures is so small, the screen is very obtrusive – only two groups red, yellow, blue and black dots being used to make up the face of the young man in the foreground. The second card from the Kunsthistorisches Museum in Vienna is of Vermeer's *The artist in his Studio*. Here the painting is made up of large forms and shapes, and although the same screen has been used as on the Giorgione, the dots are not at all noticeable. The conclusions are fairly obvious. Subjects most suited to small-scale reproduction are those made up of relatively large forms; when detailed subjects have to be reproduced on a small scale, the finest possible screen should be used. Normally 150-line for letterpress and 175 for offset. In fact I would suggest that here 150 lines should be the minimum requirement for either process.

THE LARGE PICTURE BOOK

What degree of faithfulness should one look for in a reproduction for books that are intended as things to delight the eye? And not only what degree, but what kind of faithfulness?

One kind of faithfulness that is certainly not fashionable now, was the literary faithfulness shown by the Arundel Prints. The Arundel Society, that produced these prints, had been formed in 1849. It was inspired by Ruskin to

reproduce Italian frescoes, many of which were fast disappearing from the effects of rain, damp and old age. Artists made faithful watercolour copies of these frescoes, which were brought back to England and handed to the lithographer. He, in his turn, made yet another faithful copy on the stone, under the severe guidance of the art historians for whom he was working. These were careful works of scholarship, accurate in every scholarly detail and about as visually like the originals as one might imagine they would be! Christian Barman, writing some years ago of these Arundel Prints, said: 'As translations they had the same qualities of scholarship, accurate in every scholarly detail as our best translations of Homer and Dante.'[1]

The operative word here is 'translation' as opposed to imitation. For very accurate monochrome reproduction, and for limited runs the best results are produced by collotype. And for longer runs, by 300-line offset lithography, and, if expense is less important, by rotary gravure. The ordinary processes of letterpress (150-line screen) and offset are less effective at this level of work which is, however, outside the normal commercial requirements of most publishers, museums or art galleries. The virtues and limitations of these fundamentally expensive processes are discussed later in this chapter.

THE LARGE PRINT

The problem here, as we see it, is to produce a reproduction of a painting that is a satisfactory thing in itself, and not just a poor echo of a work of art. Any attempts at 'imitation' oil painting, by 'bumping up' the surface of the paper or giving it an embossed canvas grain should be avoided.

The reproduction should stand on its own merits, within a white paper mount (i.e. this can well be the paper on which it is printed), with details below of the picture and the reproduction, just as the mezzotinters and aquatinters did with their prints (see page 23). A reproduction of this kind will stand framing. The reproduction oil painting, set in an ornate gold frame as if it was the real thing, degenerates only too quickly into *kitsch*, to match up to so much else that is imitation in contemporary life. Far be it from us to lay down the laws of taste in such a matter. All we are trying to say is that a really good colour photo-reproduction of a painting is often a marvellous thing in its own right, and should not be ashamed to proclaim its origins.

In photographing paintings for reproduction, it is as well that the photographer should understand something of the nature of the painting; for this

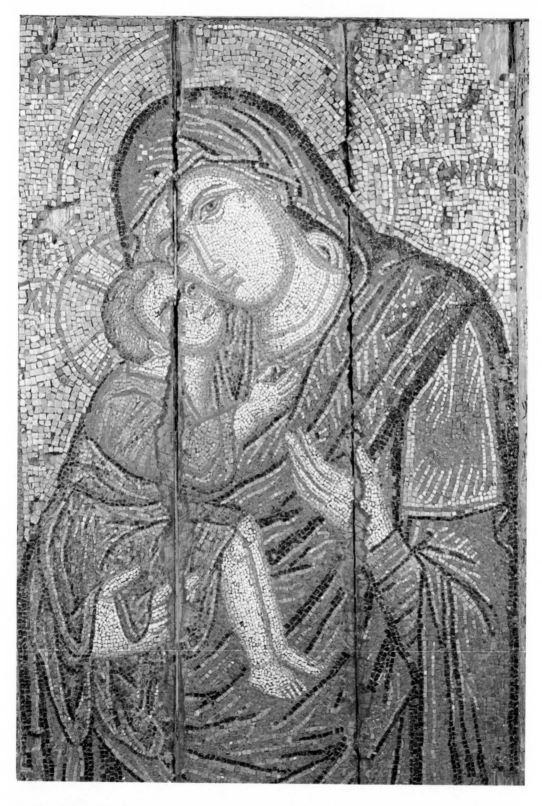

Both these subjects were photographed with two 500-watt lamps on Ektachrome 'B'. Reproduced from the colour transparencies and printed by offset lithography in four colours from 150-line screen plates.

Virgin and Child. Mosaic, Asia Minor 14th century. 38″ high.
By courtesy of the Byzantine Museum, Athens.

Saint. Fresco undated, early Christian (50″ high).

By courtesy of the Byzantine Museum, Athens.

understanding should help him to emphasize some of the basic characteristics and qualities of a work of art. A painting, physically speaking, is composed of a background or a support, which may be of wood, canvas or paper, millboard or the brick or stone of a wall; on this may be laid a ground of gesso and a priming consisting of a thin layer of paint or size, then comes the actual layer of paint and finally a protective coat of varnish.

A painting's appearance to the eye, is governed by its capacity for absorbing or reflecting the various component parts of white light. So, for instance, if it absorbs the blues and reds, it will reflect the yellow and so will look yellow. Various things govern this, including the actual size to which the grains of pigment are ground.

There are six basic types of painting, which can be grouped under the following headings: pastel, watercolour, fresco, tempera, oil and acrylic.

Pastel was not widely used as a medium before the eighteenth century. It has a limited colour and tonal range, for the filler used with the colour is either white pipeclay or whiting, hence the soft, so-called 'pastel' shades. The binding medium is gum tragacanth and support is usually paper, which is sometimes given a sandpapery appearance by the addition of finely ground pumice stone. This is to help the pastel to adhere to the support. As a result of this textured surface, the background is usually a middle tone and only rarely is it white paper. Examples: works by Degas, Toulouse-Lautrec, Chagall.

Watercolour is one of the oldest methods of painting. It was used on vellum in the Middle Ages for decorating missals and other manuscripts, it was used even earlier in China on fine silk. Since the fifteenth century it has been used in Europe on paper. In watercolour, the finely ground pigment is mixed with gum arabic, a medium that is soluble in water. When painting, the water evaporates, leaving a coat of paint on the paper, or whatever other support is used. Gum arabic is somewhat brittle, so sugar, glycerine or honey is added. It is a transparent medium, so light is reflected from the paper as well as from the minute particles of pigment. Examples: works by Rossetti, Birket Foster, Turner, Cotman; also vellum manuscripts and Chinese silk paintings.

Opaque watercolour, called either gouache, body colour or poster colour, is almost as old a medium as its transparent cousin. In fact the media have often been combined in one painting. In gouache, the pigments are mixed with zinc white (Chinese white), so the colour range, like pastel, is limited, more so than the transparent watercolours. Examples: Seventeenth-century Indian paintings

(see page 39), and works by James Pryde, Turner.

Fresco is the name given to watercolour painting on plaster. There are two methods: 'fresco secco' and 'buon fresco'. In fresco secco, the painting is on dry plaster, in buon fresco, the painting is done on wet plaster, so the pigmentation is in some depth. Examples: works by Fra Angelico, Giotto, Correggio, Piero della Francesca.

For tempera, one uses the unlikely medium of egg, both yolk and white. The support was usually wood, sized, with a covering of thin linen or canvas and coated with gesso. The range of tone, like fresco, is limited to the upper range. There are no real darks in either of these media. Examples: works by the fourteenth-century Sienese painters.

Oil painting was first used in the fifteenth century, apparently by the Flemish painter Jan van Eyck. Van Eyck's methods certainly caused a radical change in the technique of painting. His way of painting, was to start with a mono-chrome tonal design, and then over this under-painting to paint on layers of transparent colour in the form of glazes, a scrumble of opaque colours, and solid highlights. The tonal range, in comparison with any of the previous methods of painting was enormously increased, ranging, as it did, from white to almost black. This method, that Renoir called 'bitumen' painting, remained in use at least until the time of Turner. It was finally discredited, if that is the right word for the works of such artists as Rembrandt or Vermeer, by the discoveries of the French Impressionists, particularly Monet and Seurat. With the help of the research work done by Herman von Helmholtz, into the nature of light and colour, these Frenchmen began by limiting their palette to the colours of the spectrum, dispensing entirely with the use of browns and black. On occasions, they did not stick too rigidly to this but 'the influence of the Impressionists on the colour analysis in modern painting has been profound'.[2]

[2] *The Painter's Workshop*. W. G. Constable. Oxford University Press, 1954.

The same researches that led Manet, Degas, Monet, Sisley, Seurat and Renoir into one of the most magical periods of painting, was also the starting point for modern trichromatic colour reproduction.

An understanding of the techniques and the materials that an artist has used, should be some help in the choice of medium for reproduction, and also on the kind of lighting one may need to use when photographing these works of art.

For faithful colour reproduction of both pastels and watercolours, offset would seem the obvious choice; certainly in reproducing watercolours it should be possible, within reason, to match the kind of surface of the paper the artist may

Tempera painting

Abraham Entertaining. Tempera 14th century (13″ × 23″).
Photographed with two 500-watt lamps on Ektachrome 'B'.
Reproduced from a colour transparency and printed by offset lithography in four colours
from 150-line screen plates.
By courtesy of the Benaki Museum, Athens.

46

Rocky Mountains and Tired Indians (67″ × 99½″) by David Hockney. Acrylic paint on canvas, 1965. Reproduced from a colour transparency and printed by offset lithography in five colours from 150-line screen plates.
By courtesy of the Peter Stuyvesant Foundation © the artist.

have used. This and the use of a fine screen (150-line) should result in a very fair representation of the original. Of course it is not a facsimile – anything with a screen visible on close scrutiny – cannot be more than an approximation.

Pastels with their essentially matt surface would suggest offset and once again a matt cartridge paper. Side lighting of the original may be necessary if it has a textured surface.

Frescoes, with their limited high tonal range, but smooth surfaces could be reproduced by either letterpress or offset. We would think offset on a coated cartridge paper would be the best solution.

For both tempera and gouache, either process could be used, again using a smooth paper for offset printing.

For oil paintings we suggest the use of letterpress printing. The 150-line screen, four-colour half-tone plates, modern inks and China-clay-coated papers still result in the richest colour range and most brilliant result. It is obviously impossible by the use of printing inks and paper to duplicate the – sometimes – heavily loaded, undulating three-dimensional surface of an oil painting. The resource, after printing, to embossing the surface of the paper to represent impasto is too contemptible to consider seriously. However, by judicious side lighting, much of this three-dimensional quality can be shown. This method of side lighting almost certainly means that the first stage of the reproduction must be a colour transparency. If it is reproduced by an electronic drum type scanner, the use of a transparency is obligatory.

Lastly, acrylic resin paints, which have recently been adopted by artists for the painting of pictures, provide the painter with a medium for producing strong, bright, flat colours. David Hockney's *Rocky Mountains and Tired Indians* is an acrylic painting on canvas. Apart from its size (67″ × 99½″), it offers no particular difficulty for reproduction. It is here reproduced from a transparency on a drum scanner and printed by offset lithography in four colours.

Opposite:
Entrance for a Red Temple No. 1, 1960 by Alan Davie. Oil painting on canvas (84″ × 68″). Reproduced from a colour transparency and printed by gravure in four colours.
By courtesy of the Trustees of the Tate Gallery, London. © the artist.

3 The photography of paintings, drawings and prints

In photographing pictures in galleries, the usual procedure nowadays is to make a colour transparency such as an Ektachrome or an Agfacolour. Half plate $6\frac{1}{2}'' \times 4\frac{3}{4}''$ or $5'' \times 4''$ are the sizes most normally used. With the introduction of scanners, there is no longer any need to make separation negatives.

Making an accurate colour transparency of a painting is perhaps one of the least creative of a photographer's tasks. If he is sensitive to painting, there will be, if the work is admired, the consolation of having it to himself and of paying it the ritual homage of his own craft; though this pleasure may turn to torture when the work is despised – a condition not infrequent enough to be ignored! Since the purpose of the transparency is to provide material for a printed reproduction, the photographer is only a convenient bridge between the painting and the printer. Wherever possible his role should be omitted by taking the original to the photo-engraver, unless it is to be reproduced by means of a drum scanner. In any case the printer's proofs should be corrected from the original rather than the transparency.

Most forms of photography involve choice, at least of view-point, of lighting and of exposure. Here there is none. The camera must be square on to the picture; all of the picture, at least under most circumstances, must be included; and its every square inch lit with equal intensity. To these implacables are added inflexible exposure times (1/50th sec. for the daylight type of film and $\frac{1}{2}$ sec. for the artificial) and standardized processing.

Only under controlled and permanent conditions can all these requirements be conveniently and efficiently fulfilled and repeated. The production of copy-transparencies of scientific accuracy should therefore be properly carried out in a studio laboratory, which is part of the photographic department of a national museum or art gallery. But ideals notwithstanding, the occasions on which an original can be loaned to the platemaker will be rare. And works of art must frequently be photographed in private homes or in small galleries where it may not be easy, casually and temporarily, to achieve a sufficient intensity of evenly distributed light to make the mandatory ideal exposure.

Two 500-watt lamps disposed on either side of the subject, angled to cause no reflected glare from glass or varnish and sufficiently removed to give an even light of moderate power, can be made to illuminate an area of about six feet by three feet to the intensity necessary for an exposure of about half a second – at an aperture somewhere between f.6·3 and f.11 depending on the luminosity of the painting itself.

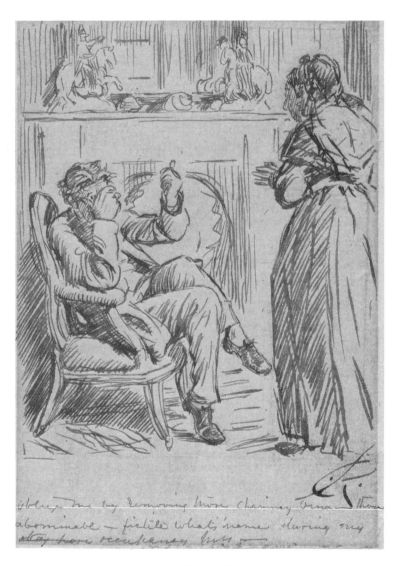

Aesthetics drawn in sepia ink by Charles Keene as an original for *Punch*
(5½″ × 4″). August 1868. The diluted inks he used make a photographic
line reproduction virtually impossible. This is reproduced in sepia from
300-line screen half-tone and line positives and printed by offset lithography
(see page 28).

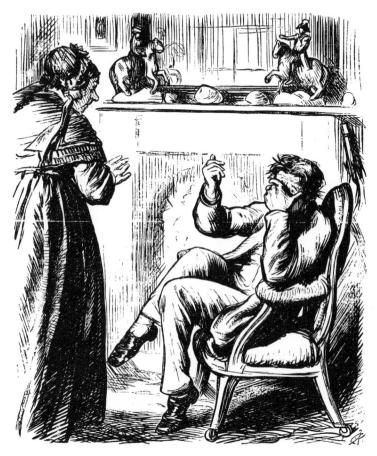

ÆSTHETICS.

Fadsby (in agony ; he's a martyr to the decorative art of the Nineteenth Century).
"OH! MRS. GRABBIT—I REALLY MUST—IMPLORE YOU—TO REMOVE THOSE CHIM-
NEY ORNAM——UGH !—THOSE TWO—FICTILE ABOMINATIONS—FROM THIS ROOM
WHILE 1 REMAIN HE-AR !"
[*Of all the Artis's, Mrs. Grabbit said, as she 'd ever let her Apartments to, he was
the most partic'lar.'*

Aesthetics ($5\frac{1}{2}"$ × $4"$). The wood engraving for Charles Keene's drawing, repro-
duced and printed by line offset lithography. The reason that the illustration
above is facing the opposite way is that it would have been traced down or
photographed on to the wood block the right way round and then it would of
course print the opposite way.

The optimum exposure of half a second should be achieved by adjustment of the lens aperture rather than bringing the light nearer to small paintings.

Should the necessity arise of covering larger areas or of disposing the lamps at a greater distance to avoid reflection or glare, the level of the light will fall below the half-second exposure line – even should the risk be taken of using the lens at its largest aperture. The photographer then has recourse, with a slight loss of confidence, to the 'Supplementary instructions' packed with the film. These vary from one batch to another. Consulting a current sheet, he may find that the exposure may be prolonged to five seconds without upsetting the colour balance. Beyond that, the use of a recommended colour-compensating filter will, with that batch, extend the time to thirty seconds.

Longer exposures permit of a more resourceful use of limited light sources than symmetrically disposed lamps. It becomes possible, for instance, to divide the exposure into two equal halves using all the light on one side of the picture for the first half and transferring it to the opposite side for the second half. This enables a larger area to be covered in an upward direction. Yet more range can be obtained with a hand-held lamp, brushing the light over the area in bold and regularly repeated sweeps – having made certain in advance that the positions from which one is working are not reflecting points. Here also it will be as well to divide the exposure and work both sides of the camera and subject.

Correct exposure times for procedures like those described, can only be found by trial. A log-book of exposures and conditions, including light readings, and marked with subsequent valuations of success or failure will be of more use than an exposure meter – strict reliance on which may lead to under exposure. This is probably due to the fact that 'correct' exposure is calculated on the basis of a lens focused on infinity and all copying is done at closer proximity. Increase of bellows extension involves increase of exposure, but this may be considered negligible until any lens is used nearer the subject than eight times its focal length. From such a point until the distance is decreased to twice the focal length for full-sized copying, the necessary increase in exposure moves from a little above zero to an approximate four times. A precise basis for calculation, based on the inverse square law, can be found in good photographic manuals – but experiment and note-taking is a better guide.

An alternate source of artificial illumination is by flash bulb or electronic flash. Its general disadvantage is the difficulty of pre-judging the effect of the angle of light and of its brilliant reaction on particular surfaces. The chalky surface

Opposite:
Hollyhocks and other flowers in a vase. Oil painting by Jan van Huijsum ($24\frac{1}{2}'' \times 20\frac{1}{2}''$) reproduced from a $10'' \times 8''$ colour transparency and printed from 150-line screen letterpress half-tone colour plates.
By courtesy of the Trustees of the National Gallery, London. Museum photograph.

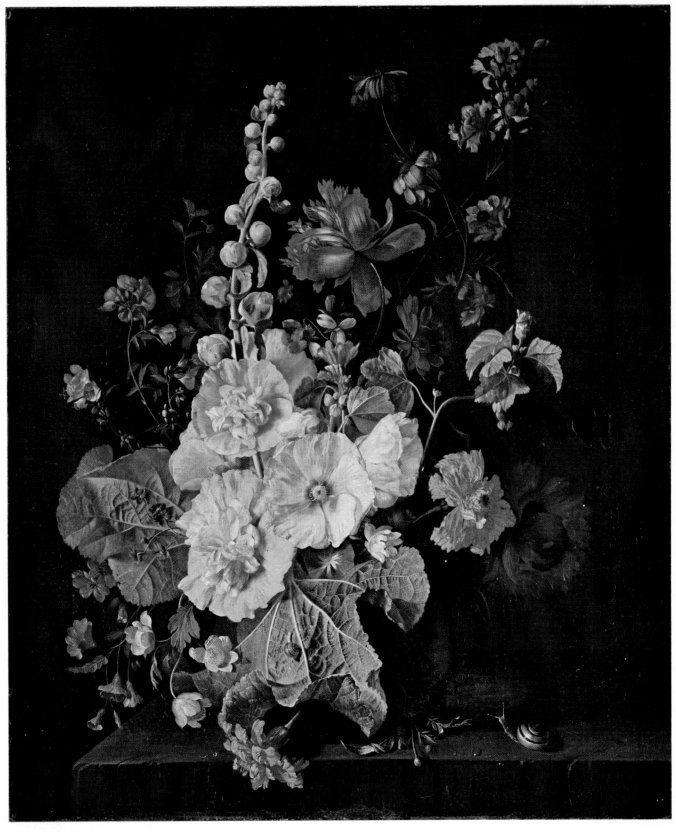

D*

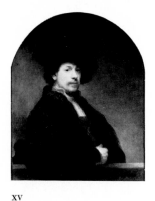

xv

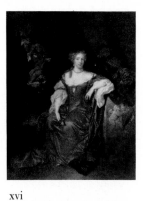

xvi

Portrait

Paulus Moreelse 1571–1638
Michiel van Miereveld 1567–1641
Frans Hals 1580/4–1666
Gerard van Honthorst 1590–1656
Thomas de Keyser *c.* 1596–1667
Rembrandt van Rijn 1606–69
Jan Lievens 1607–74
Gerrit Dou 1613–75
Bartholomius van der Helst 1613–70
Gerard ter Borch 1617–81
Jan de Bray 1626/7–99
Nicolaes Maes 1634–93
Caspar Netscher 1635/6–84
Joseph Israels 1824–1911

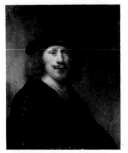

xvii

Influenced by Rembrandt (1606–69)

Gerrit Dou (portraiture and genre) 1613–75
Govert Flinck (portraiture) 1615–60
Ferdinand Bol (portraiture) 1616–80
Philips de Koninck (portraiture and genre) 1619–88
Carel Fabritius 1622–54
Nicolaes Maes (portraiture and genre) 1634–93

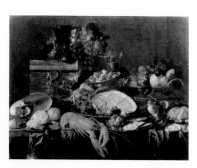

xviii

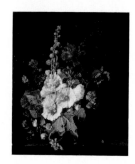

xix

Still Life, Fruit and Flowers

Frans Snyders 1579–1657
Willem Claez Heda *c.* 1593–1680/2
Jan Davidz de Heem *c.* 1603/6–83/4
Jan Baptist Weenix 1621–*c.* 60
Willem Kalf *c.* 1622–93
Cornelis de Heem 1631–95
Abraham Mignon 1640–79
Rachel Ruysch 1664–1750
Jan van Huijsum 1682–1749

Key to illustrations on pages 92–5: i Cornelis van Haarlem: *The wedding of Pelée and Thetis* (Frans Hals Museum, Haarlem); ii Gerrit Berckheyde: *The market place and the Grote Kerk at Haarlem*; iii Jan van de Cappelle: *A coast scene with a small Dutch vessel landing passengers*; iv Paulus Potter: *Cattle and sheep in a stormy landscape*; v Meindert Hobbema: *Landscape with a stream and several watermills*; vi Van Gogh: *View at Auvers* (Tate Gallery, London, courtesy of the Trustees); vii Jan Vermeer: *A young woman seated at a virginal*; viii Gabriel Metsu: *A woman seated at a table, and a man tuning a violin*; ix Nicolaes Berchem: *Allegory of the growth of Amsterdam* (Municipal Museum, Amsterdam); x Philips Wouwerman: *Cavalry making a sortie from a fort on a hill*; xi Rembrandt van Rijn: *The woman taken in adultery*; xii Hendrick Terbrugghen: *Jacob reproaching Laban for giving him Leah in place of Rachel*; xiii Van Ostade: *An alchemist*; xiv Gerrit Dou: *A poulterer's shop*; xv Rembrandt van Rijn: *Self-portrait at the age of 34*; xvi Caspar Netscher: *Portrait of a lady in yellow*; xvii Govert Flinck: *Portrait of Rembrandt*; xviii Jan Davidz de Heem: *Still life with a lobster* (Wallace Collection, London, by permission of The Trustees); xix Jan van Huijsum: *Hollyhocks and other flowers in a vase*. Unless otherwise stated, all pictures by courtesy of The Trustees of The National Gallery, London.

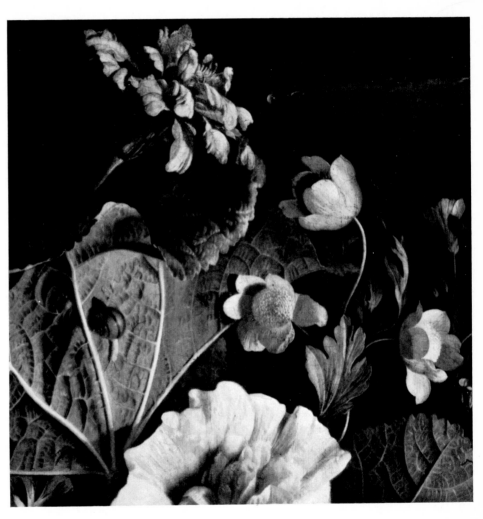

A monochrome detail from *Hollyhocks and other flowers in a vase* reproduced to the same size as the original painting. Printed by letterpress from 150-line screen plates.

Opposite:
A page from the B.B.C. publication *Dutch Painting* printed by letterpress with 150-line screen monochrome half-tone plates. Note that No. xix is the Van Huijsum *Hollyhocks* reproduced over the page. Reproductions of this size are only for identification purposes. The finest available screen is essential when working to this scale.
By courtesy of the B.B.C. and the Trustees of the National Gallery, London. Museum photographs.

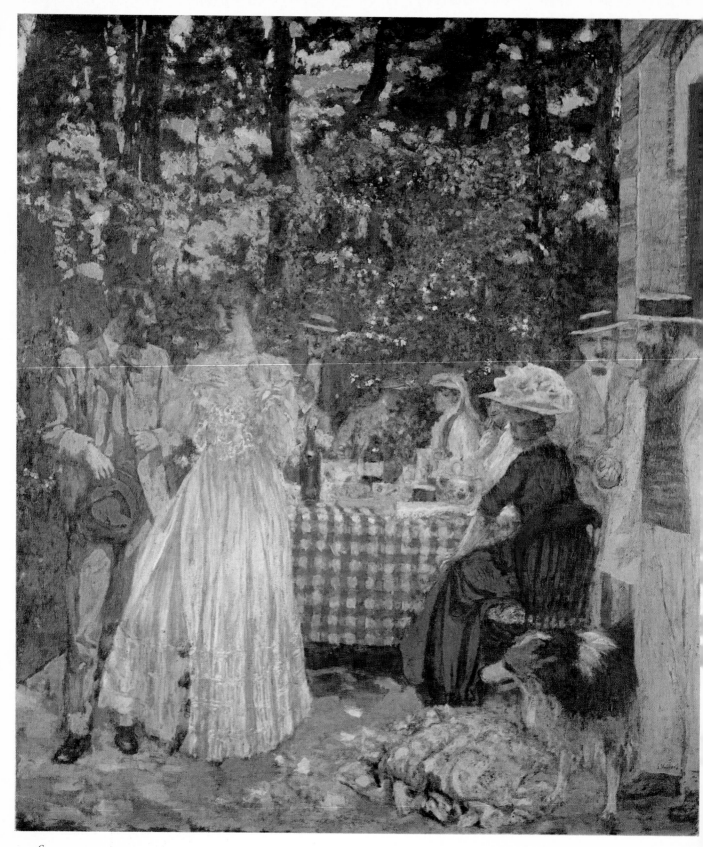

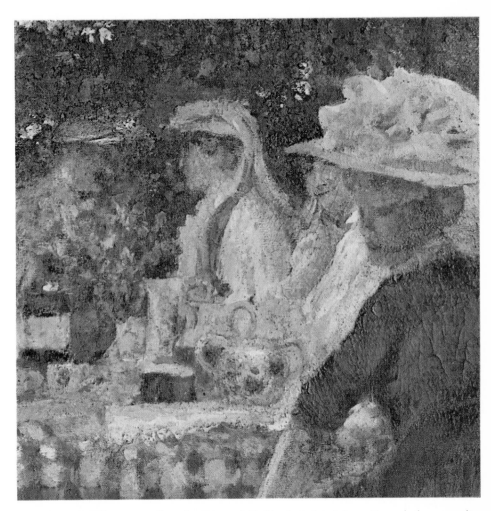

Le Déjeuner à Villeneuve-sur-Yonne by Edouard Vuillard. A detail from the painting opposite, reproduced from the same colour transparency and printed by letterpress from 150-line screen half-tone plates.

Opposite:
Le Déjeuner à Villeneuve-sur-Yonne by Edouard Vuillard. Oil painting on canvas (80″ × 75″). Reproduced from a 10″ × 8″ colour transparency and printed by letterpress from 150-line screen half-tone plates.
By courtesy of the National Gallery, London. Museum photograph.

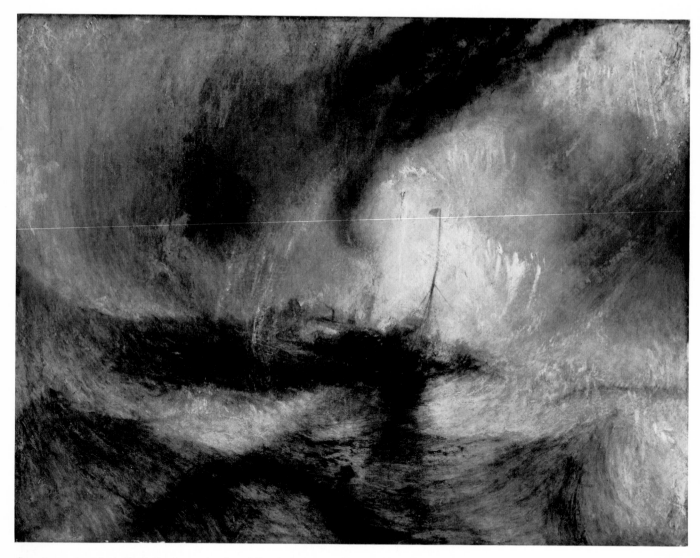

Snowstorm: steam-boat off a harbour's mouth. 1842. Oil painting by J. M. W. Turner. (36″ × 48″).
Reproduced from a monochrome photograph. There are difficulties here as in most mono-
chrome reproductions in maintaining the tonal and colour values. On either side of the column
of smoke which rises from the tall funnel is a patch of blue sky. This pale blue photographs to
almost the same degree of lightness as the white snow cloud behind the mast. Printed by
letterpress from a 150-line screen half-tone plate.
By courtesy of the Trustees of the Tate Gallery, London. Museum photograph.

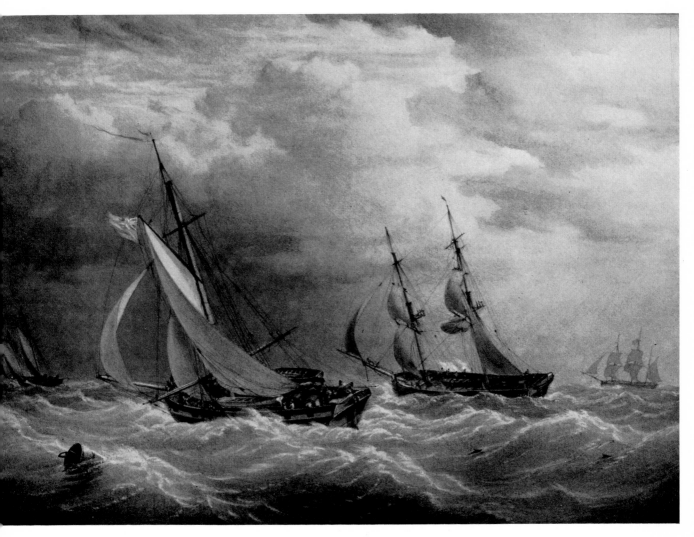

Ships in a fresh breeze: watercolour painting by W. Joy, 1856. 11¾″ × 16″. Reproduced from a monochrome photograph and printed by letterpress from a 150-line screen plate.

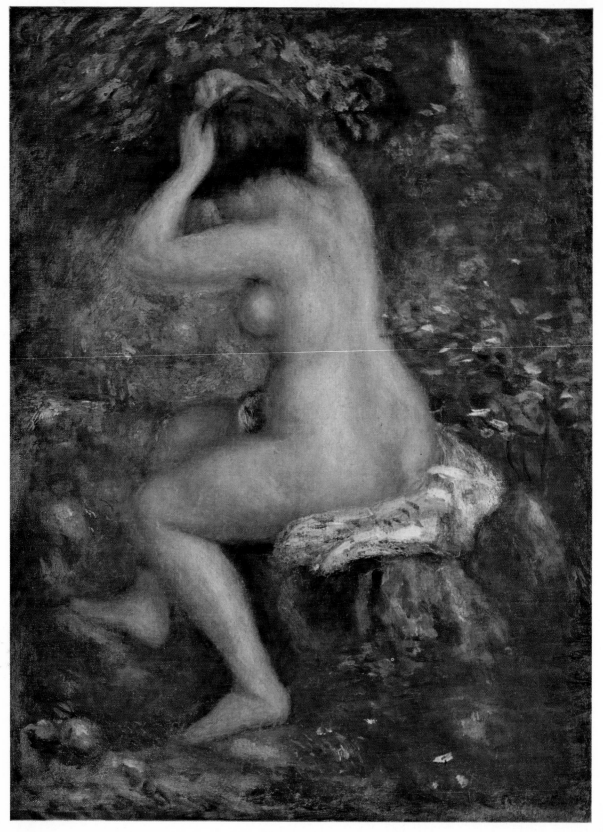

Opposite:
Baigneuse se coiffant: oil painting by P-A. Renoir (15¾″ × 12¼″). Reproduced from a 10″ × 8″ colour transparency and printed by letterpress from 150-line screen half-tone plates. In this small misty, warm painting, the blue and white towel on which the model is sitting, is, as here, slightly out of tone.
By courtesy of the Trustees of the National Gallery, London. Museum photograph.

of an old fresco takes flash beautifully; at the opposite extreme, an oil painting, particularly one with impasto or surface irregularities, is shown to disadvantage. Large areas can be covered with several bulbs in 'open flash' technique, but for synchronized flash the area covered without complicated wiring arrangements is small.

A painting is best seen in an even light of no strong direction. At least 90 per cent of the works most photographers have occasion to copy were painted indoors in diffused daylight. Since the time of the Impressionists, painters have worked also out of doors and since the Post-Impressionists also in artificial light, though in the former case in open shade. Painters in recent times have worked in diffused artificial light, or even more recently, with fluorescent tube lighting. Drawings and watercolours apart, and these because of the almost non-reflecting nature of their media, no paintings are made under lighting of a single strong direction. Heavy brushwork, modelled pigment, textures produced with sand or scored paint; the effects of all these have been calculated in an even light and for a luminosity as it were within the picture itself. To attempt to boost pigment texture with angled lighting and with cast shadows is to falsify the painting.

Even with the flattening character of two equally opposed lamps, a lens will render more surface detail and incident than is apparent to the glancing eye. Should this be felt inadequate to express the nature of the picture, then the balance of the lights should be disturbed to a minimum, bearing in mind that the photographic process, through sharpening of contrast, will over-emphasize the effect seen by the eye.

With artificial light difficulty is always found, over large areas, of keeping the light even from side to side when the opposing lamp is partly withdrawn. But any loss of illumination from side to side can in some degree be compensated in the reproduction, if clear instructions are given to the platemaker. The even nature of daylight in this respect is admirable and the quality of bright diffused daylight is in every way ideal, except for the fact that colour film is not balanced for it, but for the warmer tones of direct sunlight. Colours in shade, however luminous, are not rendered at their correct local value but have a pronounced grey-blue cast.

Should it prove possible to make use of direct sunlight, this will be found the most suitable lighting where surface texture is thought to need emphasizing. Providing, of course, that the immediate surroundings are light enough to yield reflected light on the shadow side. Otherwise this must be provided by a carefully

positioned reflector. Coloured surfaces reflect coloured light. Large coloured areas in full sunlight in the immediate vicinity of the picture are a potential source of trouble. A red brick wall, for example, can suffuse its neighbourhood with enough reflected colour to produce a pink cast on the transparency.

Apart from the effect of reflections, defective colour rendering will usually be the result of using light sources of the wrong colour temperature. Daylight, too early or too late in the day, has a red quality which produces hot looking transparencies. And the same effect occurs in artificial light for a number of reasons: old and tired bulbs, bulbs used at the wrong voltage, the use of household bulbs. The most frequent and frustrating cause of trouble is the change of voltage caused by 'load-shedding' at peak periods. An otherwise inexplicable lowering of the spirits is often the only indication to an absorbed photographer that his lights are not working to capacity. The measurement of colour temperature and the compensation for changes by the use of filters is complex and not conclusive.

Mixed sources of varied light must be avoided, such as studio lamps with domestic or with fluorescent light and above all avoid mixing artificial light with daylight. Weak indirect daylight, however, can be obliterated by two 500-watt lamps at close quarters.

MONOCHROME

It is evident that making accurate colour transparencies of flat surfaces is a task best reduced to a routine of mechanical consistency. Making a monochrome copy, on the other hand, re-introduces intelligence at almost every step. The viewpoint remains rigidly square, but lighting, exposure and type of emulsion become matters of choice. And whereas the processing of colour material, where strict accuracy is in question, is inflexible, the processing of monochrome material is another variable and a vital extension of possibilities, both in the negative and the positive processes.

Unless the subject itself is smaller, prints smaller than whole plate size $8\frac{1}{2}'' \times 6\frac{1}{2}''$ will be an inadequate expression of the labour used to produce them. Settled establishments, where picture is brought to camera, will probably use negatives of this size or even larger and print them by contact. When the camera is taken to the picture, however, the negative is likely to be half-plate or smaller, and will be printed by projection; that is, enlarged.

Kodak list their series of colour correction filters as follows:
CC05, 10, 20, 30, 40, 50, in red, green, blue, cyan, magenta and yellow. In actual practice it is rare to exceed a 20 CC filter in any colour. There is an additional range of filters which are used to compensate for variations of colour temperature. These are called the 81 and 82 series. The 81 series is *brownish* and has the effect of reducing the colour temperature, when fitted on the camera lens; the 82 series is *bluish* and has the opposite effect, *raising* the colour temperature. In practice, it is rarely possible to check colour temperature. If a variation is suspected, additional exposures may have to be made with whatever filters the photographer thinks may be suitable.

Most manufacturers list two types of colour film:
1. Daylight film, which is designed to be exposed in daylight or by use of flash (electronic or expendable blue bulbs). This film has an optimum exposure speed of 1/50 of a second.
2. Artificial light film (Kodak type B) designed for use with artificial light having a colour temperature of 3,200° Kelvin at an optimum exposure of half a second.

Should it be necessary to use colour film in daylight at a speed of longer than 1 second, it is advisable to use artificial light film with the appropriate colour temperature correction filter. (In the case of Kodak film, this would be 85 B.)

Contact printing needs a robust negative with tonal gradation from maximum density to complete transparency. Projection printing on the other hand needs thin density and gentle gradation. The ideal negative looks flat and even weak but will contain all detail without extremes of contrast. In the enlarging process brilliance of contrast is introduced at that stage, a negative that is already brilliant, though more impressive to the eye, will be found impossible to print well by projection.

LIGHTING
This conflict between eye and process constantly recurs. What pleases the former is invariably in excess of the latter's needs, and nowhere is this more true than with lighting. Here is needed an intensity well below that which the eye would find well lit, particularly if the source is artificial. Diffused daylight giving a reading between 5 and 7 on a Weston meter is ideal.

CAMERA
The photography of small pictures and objects of domestic dimensions involves working nearer to the subject than a hand-camera will conveniently permit. It is sometimes possible to thwart the limitations of these cameras; indeed the first copying the author attempted was with a vest-pocket size ($2\frac{1}{2}"\times 1\frac{5}{8}"$) snapshot camera whose minimum range of 1·5 metres (4·92 feet) was reduced to 9" by adjustment to the focusing mechanism and the use of a supplementary 'portrait' attachment. This gave a same-size image of a Bewick tail-piece, the admired object, with thrilling clarity – even on the dim surface of a scratched celluloid set-square which had to serve as a focusing screen.

But the only convenient instrument is the basic Stand Camera the pattern of which was established some eighty years ago: a focusing back with swing adjustment; lens panel with rising, falling and cross movements; and a bellows of at least double extension. The originals were made of mahogany and brass in quarter, half- and whole-plate sizes – the modern versions are in precision-tooled metal and almost all make a $5"\times 4"$ negative.

The veterans are perfectly serviceable, after the bellows have been renewed, being antique so to speak only in their articulation, since the negative material at one end will certainly be new and the lens at the other could, and for most purposes should, be modern. An advantage of the modern camera is that an

adaptor makes possible the use of 120 size roll film, thereby making available a wider variety of film material, which is particularly useful when working in colour.

LENS

The most used lens will probably be of a focal length normal to the camera, that is roughly equal to the diagonal of its picture size. A lens of shorter focal length, or 'wide-angle', is essential on the occasions, fairly rare, when a large picture must be copied near to, or in the copying of small drawings or objects. To give a same size image of the subject a lens must be used at twice its focal length – hence the necessity of double-extension bellows. But a fully extended bellows makes a bulky and easily shaken object of the camera. Using a lens of short focal length at double extension will make the camera little more, if any, than its normal size. The bellows space saved can be used when necessary to extend the wide-angle lens to three and four times its focal length and obtain an enlarged image of the object.

A lens of longer focal length than the norm for the camera will rarely be needed for copying, unless the picture is inaccessible, but it will be found essential for the photography of objects. It will enable the camera to be used at a greater distance from the subject without loss of image size, the gentler rendering of perspective preserving a more comely and probably truer relationship of near and far parts in a complex subject, or of separate objects in a group.

It would, one assumes, be difficult to get a modern lens that was not anastigmatic and fully colour corrected, so it is barely relevant to stipulate such a necessity for picture copying. All high quality lenses are now 'bloomed' or resin coated to minimize reflection and consequent loss of light among their several components. This practice produces images of exceptional brilliance and clarity – an almost unqualified advantage. There are occasions, however, when these qualities are not virtues; for instance, where the subject itself has an excess of brilliance and contrast (polished metal for example), or any object with a highly reflective surface, and where the problem will be to reduce rather than enhance the scale of contrast. Blooming is a comparatively recent technique and it is possible to acquire otherwise impeccably modern lenses that have not been coated.

FILTERS

For monochrome copying and for the more or less correct rendering of coloured objects, screens or colour filters will be of use. A pale yellow and pale green will be most often needed – and very occasionally an orange. Colour work of the kind covered by this book needs no filters, though for scrupulously accurate copying of paintings colour-correcting filters (they need only be gelatine) are sometimes specified by the manufacturers for a particular batch of film.

If polaroid screens always achieved their purpose they would be the most valuable piece of subsidiary equipment for copying paintings. Their power of excluding reflected or polarized light, however, appears to be effective only at unpredictable angles. When confronting a large painting square-on the glare from immovable light sources usually persists, however hopefully the screen is adjusted. But for the sake of the few times on which it is found effective it must be considered a worthwhile piece of equipment.

FILMS

Panchromatic emulsion is essential for the monochrome copying of coloured objects. A fast and a slow variety will be needed – not for their speed, as in this kind of work the length of exposure is of relative indifference, but for their variety of contrast. The fast emulsions in general will yield images of weaker, the slower ones of stronger, contrast. By using a soft-working, fine-grain, developer with the fast emulsion and a harder developer, or one of the acutance type, with the slow, these qualities can be extended and exploited to great advantage – so that at one end of the scale it will be possible to subdue extreme, unpleasant and otherwise unmanageable degrees of contrast, and at the other so to stimulate slight tonal differences as to yield an image of an original so dim as to be barely visible.

This range will be enough to cover most subjects. But in the case of non-coloured originals such as prints, drawings or faded photographs, plates of the type known as Ordinary or Regular can be useful. Their real advantage is that they can be developed by observation, a welcome darkroom diversion, and the development stopped at any required point of contrast.

COLOUR

Kodak Ektachrome is the only available colour film in sheet form in Britain. There are two types: for Day and for Artificial light. If the camera will take a roll-film adaptor, use can also be made not only of emulsions of other speeds but

the products of other manufacturers. As with monochrome emulsions the higher speed colour films have a softer contrast than the slower, and the colour rendering between different makes of film varies considerably, notably in this quality of tonal contrast and gradation. These variations will not be relevant for accurate flat copying but will be very useful for three-dimensional work where the element of atmosphere becomes of interest and importance.

FURTHER USES OF FILTERS

A panchromatic emulsion, the most fully colour sensitive available, will render blue too high in tone in daylight and red too high in artificial light. Thus adjacent areas of pale blue and near white will not be well differentiated in the one case; and full reds will match, in tone, some greys and yellows in the other. This is not always important – where the painting, as in many old works, has been conceived in terms of light and shade for example. But where the work has clearly been organized in terms of colour, the case with most paintings done in the last hundred years, serious falsification can result if these odd renderings of tone are not corrected. A pale yellow filter in daylight and a pale green in artificial light will restore the balance.

The colour filter's characteristic of favouring colours of its own range can be used to great advantage when copying paintings half-obscured by yellow-brown varnish. A deep orange filter will penetrate this and restore contrast to obscure areas; and a similar colour will diminish, sometimes to the point of invisibility, the 'foxing' stains on old prints and drawings. In the less likely event of any paper original being marred with blue or green, such marks or stains can be rendered less obtrusive by the use of filters of a similar colour. But in this case complete success will depend on the use of an orthochromatic emulsion.

The opposite necessity – of increasing rather than diminishing the visibility of any colour, which arises in the case of copying faded documents, drawings or photographs – makes use of the filter's characteristic of intercepting its complementary. Fading commonly produces a weak yellow-brown image the approximate complementary of which is blue-green, and a filter of such colour will increase the contrast between figure and ground even to the eye. This distinction will be held only weakly on panchromatic emulsion, which is red-yellow sensitive, but strongly on orthochromatic which favours blue-green. These observations are correct for daylight, which is blue in character, but would need modifying for artificial light which subdues blue and favours red.

Under ordinary circumstances, where a faithful rendering of the subject is required, an exposure fuller than that indicated by an exposure meter together with development by a fine-grain process will produce the best kind of negative for projection printing. When the subject is in a poor state, dimmed by dirt or varnish, faded, or feeble in contrast from any unintentional cause, and where the photograph is intended to be clearer than the original, then the relation of exposure to development becomes a factor in the clarifying process. Long exposure is then to be avoided for its tendency to impair definition and reduce contrast by the spreading of light areas into dark. For subjects where the intended result is a dark figure on a light ground exposure should be spare and development prolonged. Use a slow or medium speed film as high speed material will fog with prolonged development.

For dark toned paintings, or where for reasons beyond righting one is forced to make the exposure in very weak light, a spare exposure on slow film and the use of an acutance-type developer will produce a negative from which prints of surprising detail and clarity of tone can be obtained.

In cases of extremely faded originals, such as old and pallid photographs, it may even be necessary to copy in two stages before an image of near normal contrast is established, i.e. to copy the strongest print made from the first copy-negative. Sometimes a better plan, particularly if the original tends to be linear in character rather than of broad masses of tone, is to copy the positive image that will be found to reflect strongly off the surface of the copy-negative in an oblique light – when it is seen against a very dark ground.

Care should always be taken, when pushing poor contrast to a brighter pitch, to preserve in the copy some character of the paper texture and tone of the original. In this respect of course a copy of a photograph has the unique advantage that the material of the copy is identical with that of the original and all is gain when the yellow ground of the latter is transformed to its original white condition.

All drawing papers, however, have a surface texture which lowers their tone; and not even the whitest can be acceptably treated as toneless in a photograph. To render any drawing so would be barbarous, but even printed material (engravings, etchings, lithographs, woodcuts, etc.) loses its pictorial character and scale when translated into diagrammatic black upon white.

The loss of paper tone is really a risk of contrast forcing. A correctly exposed negative will indicate paper irregularities even under flat lighting conditions,

so avoid the opposite trap – of suggesting, by excessively oblique lighting, that every surface is sandpaper. Textured surfaces that bear a picture or motif (i.e. needlework, tapestry, carpets, etc.) will suffer under this treatment, and emphasis of their texture will always be made at the expense of breadth of any design.

It is better therefore to keep the lighting scheme only barely off balance and rely on the intensifying and clarifying nature of the photographic process to look after surface texture.

In monochrome work over exposure will be fatal for the rendering of subtle ground-textures or paper tone, and even more disastrous with colour material where near-whites will tend to bleach out. A clear-ground transparency is even more dismaying than a white-ground print, and it is safe practice in colour work of drawings, prints, manuscripts and other pale-paper subjects to err on the side of under-exposure by up to half a stop. This gives a denser transparency with good ground tone. Deeply textured carpets and tapestries on the other hand, because of the larger total area of shadow caused by surface irregularities should receive the full exposure.

STAINED GLASS

Stained glass is almost the parent of the photographic colour transparency and no two processes could be more perfectly adapted to each other. The medium of both being coloured light there are no problems of translation comparable to the recording of coloured surfaces.

Bright diffused daylight is the best medium. Either a slightly clouded day, or, when there is sun, working away from its source – south and west windows in the morning, east in the afternoon. Direct sun is undesirable not only because of glare when the window includes areas of very pale or even clear glass, but because external incidentals – the horizontal reinforcing bars and the wire mesh frequently used as protection become much more evident.

As the sensation of colour is directly transmitted rather than reflected the difference in colour temperature between direct sunlight and shade is insignificant and has no apparent effect on the transparency.

4 Graphic reproduction methods and processes of printing

The initial steps in graphic reproduction are the same for all modern processes of printing. Of these different processes, the two in most common use are offset lithography and letterpress. The other processes are photogravure, collotype and silkscreen. Of these, photogravure is the only possible alternative to offset or letterpress for quality production, but is used far less than these processes because of the initial difficulties and expenses of engraving the copper cylinder. Collotype, it is sad to say, is a process little practised nowadays, though there are one or two firms in Great Britain that still run collotype presses.

Silkscreen, once regarded as a very crude method of graphic reproduction, has improved greatly over recent years and certainly has a place in this summary of graphic processes.

OFFSET LITHOGRAPHY

For colour reproduction for offset (and all the other processes) there are two alternative methods in use today:

 1. The conventional methods of darkroom camera, contact frame etc.
 2. The electronic colour scanners

The choice of one or other of these methods is governed by the type of original and also the size of the enlargement. Where a big enlargement is needed, the darkroom camera or vertical projector are the only possibilities. Darkroom cameras will take continuous-tone negatives from sizes of 20″ × 16″ up to 40″ × 40″; for prints larger than the camera's capacity it should be possible to increase the enlargement at least by 25 per cent. The modern darkroom camera is a development of the gallery camera. This used plates that had to be enclosed in plateholders, which were loaded in daylight. The darkroom camera has the loading end (i.e. the back of the camera) in a darkroom. The bellows, lens and copy holder project through into a lighted studio. The camera can take either flat copy or a coloured transparency. Arc or quartz iodine lights are used to illuminate the flat copy, cold cathode light for the transparency. (Another alternative for transparencies is the use of the Pulse Xenon which provides a very powerful light. This is used for direct half-tone negatives, particularly from very small [35 mm] transparencies.)

By the use of coloured filters, four continuous-tone negatives (i.e. with no screen) are made. These negatives may be retouched for any imperfections, spots or other damage. They are then contact screened to positive film. That is, the 150-line screen is interposed between the continuous-tone negative and the

sensitized film, which will become the positive. This can either be done direct in a printing frame, or, if the final image has to be enlarged or reduced, in the camera. This actually re-photographs the continuous-tone negative, which now takes the place of the original transparency in the copy holder.

Another form of contact screening is known as the Jemsby Process. This gives higher definition of very fine detail. The illustration of *Ships in a calm* shown on page 38, has been screened by this process. It is of particular advantage for a subject like this, where fine textures and details predominate, but it is less satisfactory for a picture or photograph that has large flat areas of colour.

To assist colour separation and to reduce hand retouching on the positive, a system of 'masking' is used. A mask is merely a negative of the original, placed against the positive film to hold back a certain amount of light for each separation. There are various kinds. The tri-pack and the silver mask are two in common use. The tri-pack is a dye-coloured negative transparency; this same coloured mask is used in the camera for each colour separation and is subjected to colour filters. The silver mask system uses two different masks, one for the red and blue negatives, the other for the black, and both in succession for the yellow.

The four positives which have been made to the actual printing size are now retouched. If any areas of the colours are judged to be too strong, these have the size of the dots reduced by etching with ferricyanide and sodium hypo-sulphate (Farmer's Reducer). Any areas not to be etched are covered with a resist. Where areas are too weak, solid colours are sometimes painted in on one or more of the positives, e.g. a red pillar box might be painted in solid on the magenta and the yellow positives. If this is done without adequate care and sensitivity, it can look very out of tone.

The positives are now ready for assembly (the equivalent of imposing a forme in letterpress printing, where colour blocks and type are locked up in a chase to make a printing surface). In offset, the equivalent printing surface is the lithographic plate. The positives are positioned on a ruled-up sheet of astrafoil in company with positives of the type etc. The whole is then exposed to a sensitized sheet of paper (diazo) to make a print for final correction and checking before the imposed plate is actually made. The edges of a set of half-tones have to be trimmed exactly, otherwise tell-tale strips of yellow or red or blue will overlap. This trim may be done at the platemaking stage, by giving the plate a second exposure with a solid mask covering the area of the reproductions. This extra

exposure 'burns' out the rough edges. The only thing left to do now is to proof the four plates. For this, standardized four-colour inks are used (International or British Standards). At the proof stage, directions for any necessary colour corrections are given and in the case of fine art reproduction, an extra colour printing might be found necessary. This rarely amounts to more than an extra working, to cover strong or difficult colours, for the range of modern trichromatic inks covers most needs of reproduction.

COLOUR PROOF CORRECTING

This can be just as important as correcting a text proof. Generalizations about warmth or coldness and about darkness or lightness are not of much help to the printer or platemaker. What are necessary are specific visual instructions, indicating what is needed by actual colour samples or guides. This may be difficult in practice, though by indicating other comparable areas of colour in the reproduction, adequate guidance may often be given. Whenever possible, the proof should be compared not only with the coloured transparency but also with the original painting. Certainly before reproduction starts, the Ektachrome, Agfacolour or whatever the transparency may be, should be compared with the original and if there are any colour deficiencies that cannot be rectified by re-photographing, explicit instructions should come with the transparency – and again these should be actual colour guides and not merely verbal instructions. One cannot stress too strongly the importance of getting the best possible transparencies. The nearer the transparency is to the original painting, the better chance there is of getting a good reproduction.

LINE AND MONOCHROME HALF-TONE WORK

Vertical or gallery cameras are commonly used for all line and monochrome half-tone work. In the case of the vertical camera, the drawing lies on a horizontal platform and the camera photographs it from above, taking line negatives to the actual printing size. For colour line drawing, filters are used to separate the colours. For half-tone work, in the case of, say, watercolour drawings, either direct screened half-tones are made to size and contacted to positive film or indirect continuous half-tones are made and then contacted through a screen to a positive. The latter method permits more retouching. The screen in most

common use for good quality work used to be 133-line, but 150-line are used widely nowadays. Above 150-line, the final result tends to flatten out the tones somewhat. For reproducing line and wash drawings, a line negative and a half-tone negative are combined.

For reproducing subjects such as old manuscripts, engravings etc, very fine screens can be used. A 200-line screen gives a good result, 300-line can give a quality comparable to collotype, but is inevitably somewhat flat. In the United States of America the 300-line screen (as, for instance, printed by Meridan Gravure) is obtained from short-run, albumen-coated plates, exposed from the negative. The practice in Great Britain of the few printers that use this very fine screen is to make deep-etch plates in the normal way, which allows more scope for re-touching and less deterioration of the plates, but there is something to be said for both methods. These fine screens must be printed on very good quality smooth stock such as a coated and calendered cartridge.

The plates used for good quality offset printing are usually of anodized aluminium, which will give a run of 80,000–100,000, or tri-metal plates. The latter have a mild steel base and are coated with copper and with a top coating of chrome. The chrome is etched through to the copper in the image areas. These plates should give runs of a million or more. Such wear as they may show is due to metal fatigue, if during the run for one reason or another, plates are taken off and put on the machine many times.

The condition of the paper is of great importance in offset (or any other) colour printing. If the paper is too damp, or too dry, too hot or too cold, register becomes very difficult, for the paper's dimensions alter between each printing. For accurate colour register, printing must be carried out under constant conditions of humidity and temperature, and the *paper must match these conditions*. (In the case of the lithographic pressroom of the printers of this book, the temperature is 70°F and the humidity 60% R.H.) The paper makers are instructed to despatch under waterproof wrappers, paper in equilibrium with this percentage of Relative Humidity. If it arrives at a much lower temperature than that of the machine room, its temperature is raised by stacking in warm bays. The temperature and humidity are checked by plunging into the stacks thermometric and hygrometric swords. The direction of the grain of the paper is of great importance to the offset printer. Normally he will ask for the grain to run across the machining direction, for in case of stretch, adjustments can be made round the cylinder, but not across it. In the case of book work, it is important to

reconcile both printing and binding needs, for if the grain of the paper does not run down the page in the bound book, it will not lie flat when opened.

Offset lithography originally came into use as a method of printing colour work on any surface, including on tin plate. With improved inks offset printers are today making more and more use of coated art papers. This can sometimes be a misuse of the process. For fine art work, certainly the most happy results can be obtained by using good quality coated cartridge papers, this gives them a pleasant textured surface and not the high gloss of a brush-coated art paper.

ELECTRONIC COLOUR SCANNERS

As a very great deal of colour separation is carried out by means of electronic scanners, a brief description of these ingenious contrivances and their virtues and limitations may be of use. There are two basic types of scanner. One that operates from reflection or transparent copy, and the other (the drum type), which can only reproduce from transparencies. The Vario-Klischograph is typical of the first kind. It is used for engraving letterpress half-tone plates and for preparing half-tone positive foils for offset lithography.

One end of the Klischograph carries the optical head. The copy is placed below this head on a moving table. When the machine is set in motion, this table reciprocates, below the optical head which scans it. This optical head contains two photo-multipliers, which convert the first and secondary beams of light into tiny electrical currents. The light from an illuminated spot on the copy is picked up by the lens and passes through filters, where it is split into its red, green and blue components and is converted into electric current fluctuations by the photo-multiplier.

White (on the copy) produces a lot of current, and black produces very little. This electric current passes into an amplifier and through colour correction units. The signals transmitted by this current are corrected according to pre-set data and are then passed on to the engraving head, at the other end of the machine. The plate or foil (to be engraved) reciprocates to match the movement of the copy at the other end of the machine and the table on which the foil is mounted is turned for the appropriate screen angle. The actual engraving by stylus is done on a copper plate for letterpress, or on a sheet of 0·020 or 0·010 plastic foil covered with an opaque orange coating. This forms the half-tone image as the plastic and coating are cut away by the stylus. This engraving

needle oscillates at approximately a thousand times a second and cuts a half-tone foil for offset at 152 lines per inch. The signal controls the depth the needle penetrates the engraving surface to gain less or more tonal depth.

This very remarkable machine was invented by a latter-day Gutenberg called Hell. Dr-Ing. Rudolf Hell has invented a number of electronic devices, including his 'Hellschreiber', which was used for the radio transmission of the printed word. Dr Hell is certainly a McLuhan folk-figure of the mid-twentieth century. His great contribution to the arts of graphic reproduction was to make possible the huge increase in colour work which the older photographic and chemical methods of retouching would not have been able to meet. These older methods which are still in use, often in the same printing plant, depend on subjective and individual judgement. This, it might be thought, is not in the spirit of the age which is moving fast towards automation, not because automation is better in itself (which it is not) but because it yields far higher productivity.

The non-automative methods of photolithography depend on camera work and then on some hand retouching on negatives and positives. On the whole the scanners give greater control over tonal values.

Today more and more colour reproduction work is done from transparency originals. Though the Vario-Klischograph can handle these, excellent results are obtained from drum-type scanners, such as that made by K. S. Paul or the machine known as the Diascan, or Dr Hell's 'Chromograph'. In the Paul scanner, for example, one end of the machine has a scanning drum, the other end an exposing drum. The colour transparency is fixed on the transparent scanning drum, whilst the unexposed film is fixed at the other end of the shaft to the opaque exposing drum, for the drums are on a common shaft, driven by a synchronous motor. A fine beam of light is projected through the colour transparencies from inside the scanning drum. This beam then passes into the colour separation filters inside the machine and the red, green and blue components are projected onto a separate photo-multiplier and converted into electrical impulses. These signals pass on to an electric computer where electronic tone and colour correction take place. These corrected signals are re-converted into a light beam which implants the image on the negative film, on the exposing drum. The drums rotate in unison and the scanning and exposing light beams move slowly along the drum until scanning is complete. The exposed continuous tone separations are exactly the same size as the transparency. These separations can be enlarged or reduced and screened at the same time.

Scanning can be done at 250, 500 or 1,000 lines, depending on the quality needed.

The time for scanning at 500 lines is about one inch of drum length per minute for each colour.

The machines have their limitations, though the limitations are more in what printing inks can and cannot do, than in electronic defects. It is impossible, by the use of printing inks and paper, to reproduce the exact effect of light seen either through a stained glass window, or through a colour transparency.

The finest reproduction is of little use if the original transparency is not absolutely sharp. Any blurred edges cannot be adjusted either by the scanner or the retoucher.

At least as printers and print users, we can be grateful that they do their part of their graphic reproduction functions so effectively. After the drum scanner has produced its continuous-tone negatives, one for each primary colour and black, these are then contacted through a 150-line screen (or whatever other screen is to be used) to positive film. This screened positive is retouched, then 'patched up' on a large plastic or glass sheet, which in offset lithography, takes the place of imposition in letterpress printing, and finally it is printed down on to a light-sensitized lithographic printing plate.

LETTERPRESS

In modern block making, electronics and chemistry have changed into a largely automative activity, what was once a mysterious folk craft, where one played about with such unlikely commodities as shellac and dragon's blood. However, even today the eye and the hand of the skilled etcher is still necessary for the final stages in fine art reproduction.

For four-colour, half-tone block-making, reproduction is usually done by the means of electronic scanners such as the Diascan or the K. S. Paul. The procedure in most modern block making works is to convert flat copy into a coloured transparency (Ektachrome). These transparences are placed on the 'drum' scanners and scanned at either 500 or 1,000 lines per inch and are checked on a Densitometer before screening takes place. It is possible to scan either negatives or positives, and from these continuous-tone negatives or positives, *screen* positives or negatives are produced.

The next stage for flat-bed letterpress is, that the screen negatives are printed onto a copper plate which is coated with a light-sensitive P.V.A. resist; for this

the negative is placed in contact with the metal in a vacuum frame and exposed to either arc or Pulse Xenon lights. The plate is then developed and the image is dyed for recognition purposes, and then burnt in, to a temperature of 380°F. The next stage is for the plate to be etched in a copper powderless etching machine which etches at the rate of one thousandth of an inch per minute. The plate then passes to the fine etching stage when the retoucher (colour etcher) chalks up the plate to see what has been left for him to do. On certain subjects an hour's retouching work will be enough for the four plates. More difficult subjects such as fine reproductions of modern paintings may take up to twelve hours.

In offset, all the retouching has to be done on the screen negatives and positives; in letterpress, the bulk of the retouching is done at this fine etching stage on the actual copper plate. Here skilled artists not only work on chemical dot reduction, but also on strengthening contrasts by painting out on the block with a bituminous mixture, areas that are to be held back whilst the plate is re-etched. They also emphasize details and clear away any imperfections. The screen used for good letterpress colour work is usually 150 lines to the inch, though with copy with very fine detail, a 175-line screen may be used.

One of the marked differences in the production of letterpress half-tone blocks and offset half-tone plates, is that for letterpress you must retain the finest pin point dots in the highlights, otherwise you get the appearance of a jagged hole. In offset, these highlights can often be lost with advantage.

For printing colour half-tones by letterpress, the most satisfactory colour results come from using International Standard Colours. This range of colours gives a cleaner and purer effect than other standard ranges. Paper is of course of major importance and it is essential to use good quality coated stock. The best results can probably be obtained by high gloss surface papers.

The limits of size for four-colour letterpress blocks is about 20″ × 30″ for flat-bed printing and 30″ × 40″ for rotary letterpress. The length of runs possible for the normal copper plate is about 100,000; if chrome-faced up to 500,000; and for rotary chrome-faced copper plates, runs up to 5,000,000 have been printed.

PHOTOGRAVURE

The photogravure process is a development of the mezzotint, combined with the use of photography. It is a pleasant, if expensive, process producing on

smooth cartridge paper, both monochrome and colour prints of a density and richness that offset and letterpress can only approach on coated papers. It is an ideal process for the reproduction of monochrome photographs. The amount of pigment deposited on the paper is considerably more than by either offset or letterpress, and a coated paper need not be used. The combination of a good quality smooth cartridge and good gravure printing is, we would suggest, the most satisfactory solution to the reproduction of *monochrome* photographs.[1] For colour work it is not quite so effective. Colour photogravure reproductions of oil paintings, because of the weight of ink on the paper, can look somewhat 'jammy'. On coated papers letterpress and offset lithography probably produce a crisper result for colour work.

In photogravure, continuous-tone positives are made as for the other processes. These are photographically printed down on to a polished copper cylinder. A 150- or 175-line screen is then overprinted on this photographic image. This produces a cross line grid of acid resist lines so that after the cylinder has been etched, there is a bearing surface of these lines to support the 'scraping blade'. The depth of the etched pits between these lines depends on the amount of light that has passed through the positive, and by the strength of the etch. On occasions, middle tones can be lost unless some hand retouching work is done on the cylinders.

The cylinder is now ready for printing. It is placed on the press and its entire surface is then inked with a volatile ink and the scraping blade clears off the surplus. The ink dries quickly, both by evaporation and absorption in the paper. Because of the cost of the copper cylinders and their engraving, photogravure is a more expensive process than either letterpress or offset. It, however, becomes competitive when runs approach the 100,000 mark, and is widely used, particularly in Europe, for the printing of periodicals, where inexpensive M.F. stock can be used.

COLLOTYPE

Collotype is a slow and difficult process, unfortunately little used nowadays. However, there are still a few printers who practise the craft. It is a planographic process like lithography, but its uniqueness lies in the fact that there is no mechanical screen used. It is ideal for subjects with subtle gradations of tone, and for short runs. The most delicate effects, edges of watercolour washes etc, print perfectly. It is effective both in monochrome and in colour.

[1] A possible exception to this is offset monochrome in *two* printings on a matt coated cartridge (see pages 129–131).

The printing plate is actually a sheet of heavy plate glass. This glass has a roughened textured surface on to which is poured a photographic emulsion (albumen) and then, after this has dried, a liquid mixture of gelatine and potassium bichromate. The plate is then dried in a special light-proof, vibration-free oven. Continuous-tone negatives are made, as for the other printing processes. These are fixed in position in a printing-down frame. If more than one negative is to appear on the plate, they have to be correctly imposed as for printing, with all blank areas of the paper screened from the light, with opaque material such as tinfoil.

The printing-down frame is then placed in contact with the gelatine-covered glass plate and exposed to light. The printing surface is made by the hardened bichromated gelatine. The manner in which it hardens is in direct relation to the amount of light that comes through the continuous-tone negative. The exposed surface of the gelatine becomes finely reticulated and the areas with most light (white on the negative, black in a positive) print the darkest. When the plate has been exposed, it is placed in a tank of water for a couple of hours. It is then left to dry and mature for a day and a night, after which time it is ready for printing.

The printing press used in collotype is very similar to an offset lithographic press, except that there are no damping rollers. When the collotype plate is ready for printing, it is placed for about twenty minutes in a tank containing a solution of glycerine and water. This is absorbed by the gelatine. The degree of hardening affects this absorption, the harder the gelatine, the less moisture is absorbed. The plate is then inked, from two different sets of rollers, and printed. The degree of moisture content in the bichromated gelatine affects the gradation of the ink feed. Unless areas of the negative are opaqued out, there will be a fine grey tone over even the lightest areas of the picture.

In coloured collotype, the same procedure of colour separation is used as for the other processes. It is, of course, only suitable for very short run work (about 1,200) so has often been limited to the reproduction of large prints, intended ultimately for framing. Used as the Ganymed Press did, it is ideal for watercolour and light toned paintings. For low toned oils (such as those by Vermeer or Velasquez) the process seems to impart a slightly woolly quality, which is not entirely agreeable.

Offset lithography can be successfully combined with collotype, particularly for flat colours or tints. Collotype also provides a pleasant basis for hand colouring

by watercolour stencils. Two of the most handsome books to be produced in England between the wars were printed in this manner. We refer to the Cresset Press edition of *Gulliver's Travels*, with Rex Whistler's decorations, and the Cassell edition of *Urne Buriall and the Garden of Cyrus* illustrated by Paul Nash. Collotype needs special absorbent papers, which are marketed as 'collotype papers'.

SILKSCREEN

Silkscreen, in spite of the advances that have been made in the process over recent years, is still used almost entirely for the reproduction of showcards and posters. Yet we feel it could be of use in the graphic reproduction of works of art, particularly on a large scale.

The silkscreen process in its original form was based on the combination of hand-cut stencils and a stretched screen of silk. Paint or ink was squeezed through this, leaving blank on the paper the solid part of the stencil. The paint surfaces were flat and opaque. It has been used effectively for the reproduction of gouache drawings. In the illustrations to Moussinac's *New Movement in the Theatre*, which Batsford published in the 1930's, some very effective use of the silkscreen process was made, in some cases combined with offset. A particularly exciting example was a reproduction of Picasso's design for the backdrop for *Le Tricorne*.

The process has been developed since then, and half-tones can now be effectively used, if the scale of the reproduction is not too small. The normal screen used at the photographic stage is 133-lines to the inch. A positive is made using this screen and the screened image *is then enlarged* to whatever size is needed. On a sixteen sheet poster, the screen lines may only be 20 lines to the inch; for a 20″ × 30″ sheet, from 50 to 55 lines to the inch. Anything over 90 lines to the inch is difficult to print, though it is just about possible (at the time of writing) to produce same size stencils and so get the screen down to the original 133-lines. Because of the weight of ink and the relative crudity of the process, rather 'flat' positives have to be used. The tonal range is stepped up when the reproduction is printed, though there is a danger of these looking a little sooty. Colour half-tone work is surprisingly effective. The separation process is similar to normal offset camera work, but there is one additional stage.

Working from a coloured transparency, separation negatives are made, then using tri-pack masking, continuous-tone positives are made. These are retouched

with the usual red dye (ferri-cyanide and sodium hyposulphate) process. The negative screen is then contacted to this positive and finally the half-tone positive is made. The use of half-tone silkscreen in the graphic reproduction of works of art is probably limited to gallery posters and the like. It would show marked economies over the other processes, providing the length of the run is short.

For four-colour work by this process a run of 1,000 to 1,500 is reasonable. The papers used for this process are usually fairly heavy one-sided poster papers, carrying a loading of titanium.

For book illustration, clearly it is only suitable for short runs, though by printing a reproduction four up, more realistic figures could be reached. As an autographic process it has great possibilities.

Opposite:
Reine de Joie: 1892. Poster lithographed in four colours by Henri de Toulouse-Lautrec. Reproduced here in four colours and printed by silk screen. The flat colours in this design are ideal for reproduction by this process. If the stencils are to be hand cut a basic key drawing is needed (see page 143). This key was actually used for letterpress line plate reproduction.*

* See *Graphic Design* John Lewis and John Brinkley. Routledge and Kegan Paul: 1954.

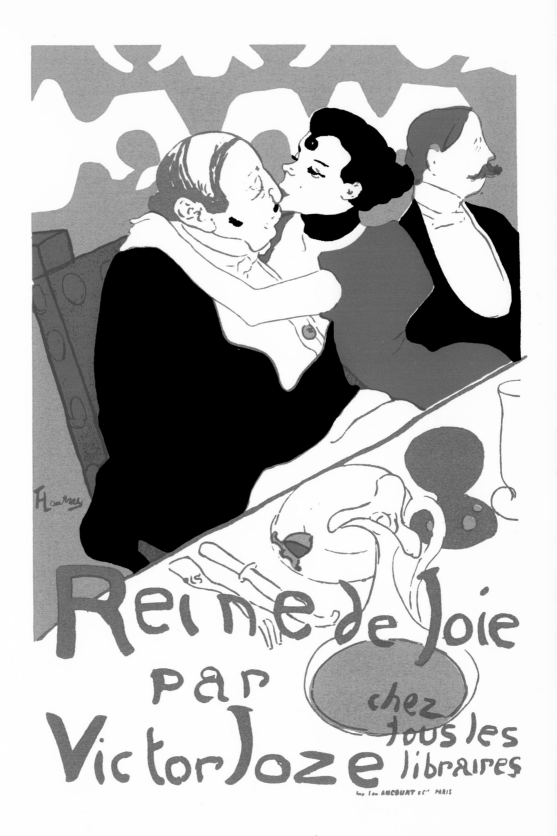

5 The preparation of copy for book illustration

The photographic reproduction of printed matter, whether it is ephemeral printing or the pages of a book, presents a rather more difficult problem than might at first sight be imagined. If the page is photographed and reproduced by either letterpress or offset half-tone, an ugly grey screen will cover what may well have been white paper. Clearly the photographer should try and keep his background as light as possible, while retaining the black of the type. But still this tone representing white paper, is going to be much darker than the actual paper on which it is printed.

This grey tone can be dispensed with by the use of line negatives which will reproduce type or line illustrations, but not the surrounding paper. If the area of the paper is to be shown, this will have to be ruled up and the photographic print stuck down in the appropriate position in this line frame. Also a combination of line for the type and half-tone for the illustration can be vignetted and placed within the same ruled-up frame.

Alternatively, a flat tint of a very pale parchment colour could be used to make up the page area around and behind the vignetted monochrome or four-colour half-tones. This will not make a facsimile of the printed page, but it is probably a good deal nearer to it in spirit than the all-over grey half-tone screen. There are exceptions to this, and with very careful lighting much of the texture and quality of the original paper can be shown. And with the use of a brown-black ink, the grey tint becomes less offensive.

Scale again comes into this kind of work. If the reproductions form part of what may almost be a catalogue, such simplifications as have been described here may be justified. If, however, the reproduction of printed illustration or book pages are to be looked at critically and judged as the originals were judged, one has to approach the problem differently. In this case the reproductions should be as nearly as possible the same size as the originals and look as nearly as possible as if it was a page from the original book.

In the case of the catalogue approach, something of the niceties of relative scale may have to be sacrificed in the interests of the design of the book as a whole. Here, as in much else in printing, one has to assess priorities.

The choice of the ideal process for the printing of reproductions of works of art is by no means always possible in book work. Long runs will probably put collotype, silkscreen or stencil out of court. Expense or plant limitation may exclude photogravure. So, for most kinds of book work, one is limited to letterpress or offset.

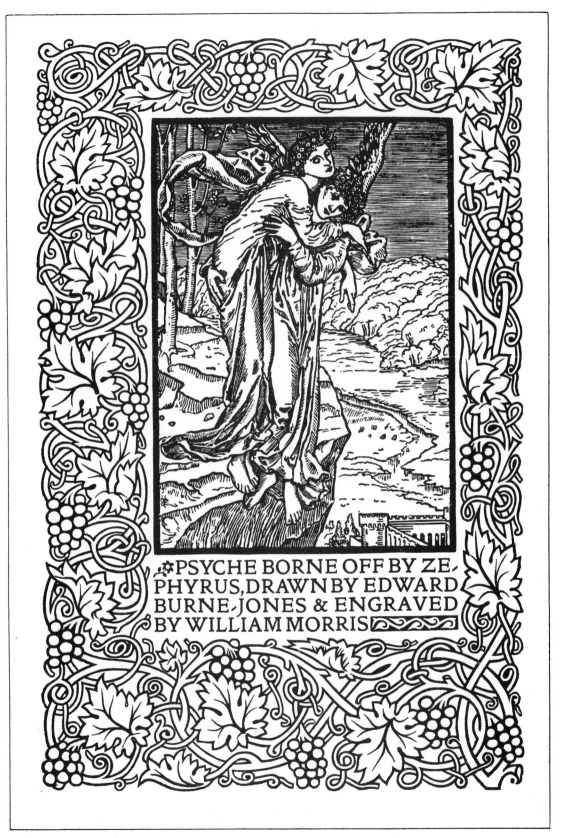

PSYCHE BORNE OFF BY ZE
PHYRUS, DRAWN BY EDWARD
BURNE JONES & ENGRAVED
BY WILLIAM MORRIS

Opposite:
The frontispiece to *A Note by William Morris on his aims in founding the Kelmscott Press*, 1898. A same size reproduction prepared by enclosing a line bromide within rules. Printed by line offset.

From *The Twentieth Century Book:* John Lewis: Studio Vista, London 1967.

Title-page from a Temperance Tract. Early 19th century (7″ × 4″). Photographed with improvised apparatus – a small hand camera with portrait attachment over lens – under diffused daylight. Slow Panchromatic film. The object of this photograph was to show the character of the book and the paper. Reproduced and printed by offset lithography from a 150-line screen plate.

Collection Mrs Nicholl, Exeter.

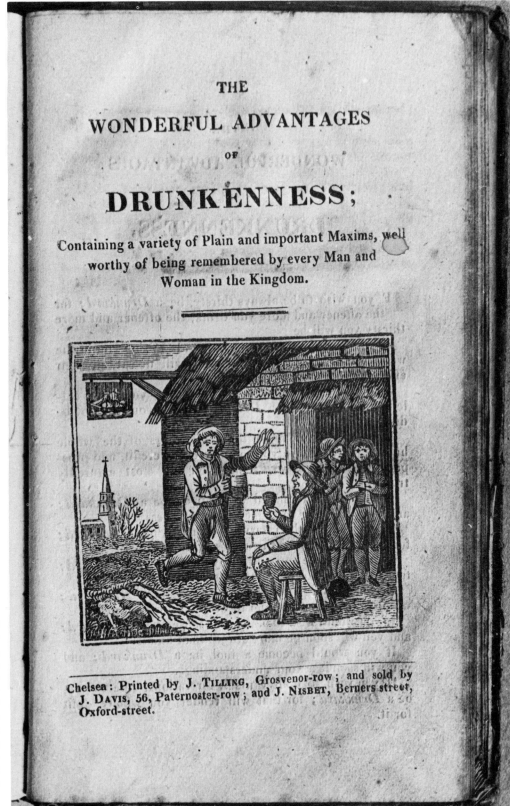

THE

WONDERFUL ADVANTAGES

OF

DRUNKENNESS;

Containing a variety of Plain and important Maxims, well worthy of being remembered by every Man and Woman in the Kingdom.

Chelsea: Printed by J. Tilling, Grosvenor-row; and sold by J. Davis, 56, Paternoster-row; and J. Nisbet, Berners-street, Oxford-street.

The choice between these two processes may be governed firstly by cost (for runs of over 20,000 offset has usually been cheaper, but this is often challenged by rotary letterpress and particularly for black and white work; secondly, by appearance. This is largely a matter of paper. For fine screen half-tone letterpress, it has to be coated stock; for offset it can be anything from a rough cartridge to a glossy art paper. If the bulk of the illustrations are monochrome half-tones, letterpress is probably the better process. Also for caption and page adjustments, it is more flexible. On the other hand, if the illustrations are mainly colour subjects suitable for the process (such as pastel or watercolour drawings), clearly offset is the better choice. Offset is also better when flexibility in the positioning of illustrations throughout a book is needed.

The production of a book with a great number of illustrations poses a number of other problems which are not limited to graphic reproduction. The actual placing and presentation of the illustrations is not the least of these. There are various ways in which a coloured illustration can be worked in the imposition of a book. On the reasonable assumption that colour is not printed on every page of the book, but that the book has, say, sixteen full colour pages and a large page area, it is probably imposed 'eight pages to view', that is it will be made up of sixteen-page sections. So, the sixteen colour pages could be printed in one section, eight colour pages backing up the other eight colour pages. Thus it would be bound into the book as a solid section of colour. This is not a very likely happening. It is more probable that the colour will only be on one side of the sheet, backed up with text or monochrome illustrations and bound into the book as four-page units, either wrapping round sections of text or being inserted into the centre of sections. Where more emphasis is to be placed on these coloured illustrations, the reverse side of the paper can be left blank, to avoid any show-through and tipped[1] or guarded[2] into the book as rectos. It is considered, perhaps correctly, that the right-hand page is visually of more importance than the left. To increase the importance of these coloured pages still more, they can be mounted on to a stiffer paper, plate-sunk and interleaved with a flimsy. The flimsy, incidentally is a necessity in the case of collotype and is an advantage for gravure, for there is a danger of set-off[3] from both processes. The actual area of an illustration in a book should normally be governed by the grid structure on which the book has been designed. Some degree of horizontal alignment with text area, headings etc is necessary to maintain a unity.

[1] Tipped-in: when an illustration is trimmed to the page size of the book and pasted at its back margin on to the following page.

[2] Guarded-in: when an illustration is trimmed about half an inch wider than the page size and is wrapped round the back of a section.

[3] Set-off: the impression from the ink of an illustration made on the opposite page of a book.

Bleeds (that is, when illustrations come right up to the edge of the paper) are effective for many subjects and give the maximum space available to them. Bleeds, however, are only suitable for photographs where these can be trimmed without detriment to the subject, by the necessary $\frac{1}{8}$″. Conversely, bleeds should never be used for the reproductions of paintings, where the whole area of the painting is to be shown, because of this necessary cropping.

PAPER AND PRINTING

The best photographic reproduction work can be utterly wasted if the work is printed on unsuitable paper. For offset lithography the choice is fairly wide; for letterpress half-tone work it has to be limited to what is, somewhat inappropriately, called 'art' paper; that is a paper with a loading of China clay and a calendered surface.

Objections are often made to art paper, but a really good quality coated paper gives great brilliance to monochrome and colour half-tones. One has only to compare a letterpress monochrome half-tone of a photograph printed on a coated paper, to an offset monochrome half-tone printed on a cartridge paper, to realize the far greater richness of the letterpress. The difference is lessened if the offset half-tone is printed on the same coated paper,[4] but the letterpress is still much richer in tonal contrast. This is not so obvious with *four-colour* half-tones. With four-colour work it is certainly sometimes difficult to be sure, without using a magnifying glass, which four-colour process has been used.

The best art papers have esparto or chemically purified wood as their body and are 'brush-coated', that is a mixture of China clay and titanium dioxide (to give opaqueness and whiteness), is brushed on while wet and dried in a current of warm air. This surface may then be calendered between polished rollers or friction glazed to produce an enamel-like finish. Art paper can be had with surfaces ranging from these brilliant finishes down to a flat matt surface. This 'matt art' looks nice, but marks easily and is less good for high quality reproduction printing.

One-sided chromo art paper is used for the printing of four-colour letterpress half-tone plates that are to be tipped-in to a book or mounted on boards. The same paper, incidentally, is used for book jackets as the relatively rough back of the paper does not slip about on the case.

For offset lithography the choice of paper is wide, but whatever papers are used, they have to have certain characteristics. These are that, in the case of

[4] Or if there are two printings from plates made with differently angled half-tone screens (see pages 129–131).

Theatre, Belfast.

By Permission of THOMAS VERNER, Esq. Sovereign.

For the Benefit of
MR. TALBOT,
AND HIS
Last Appearance this Season.

The Public are respectfully informed, that in consequence of the applause bestowed on the Play of Saturday Evening, it will be repeated on this occasion.

On Monday Evening, Sept. 23d, 1822,

Will be performed the Comedy of

KNOW YOUR OWN MIND.

Dashwould,	- - -	Mr. TALBOT.	Sir John Millamour,	-	Mr. CHIPPENDALE.
Millamour,	- - -	Mr. M'CARTHY.	Sir Harry Lovewit,	- -	Mr. SMITH.
Malvil,	- - -	Mr. HAMERTON.	Charles,	- -	Mr. DIGGES.
Bygrove,	- - -	Mr. CUNNINGHAM.	John,	- - -	Mr. HART.
Captain Bygrove,	- - -	Mr. BURKE.	Richard,	- -	Mr. JOHNSON.
Lady Bell,	- -	Mrs. T. HILL.	Miss Neville,	-	Miss CURTIS.
Lady Jane,	- -	Mrs. BOLOGNA.	Madam La Rouge,	-	Miss CUNNINGHAM.
Mrs. Bromley,	- -	Mrs. M'CULLOCH.			

END OF THE PLAY, A FAVOURITE SONG CALLED

LIVE AND BE JOLLY,
By Mr. HART.

To conclude with the popular Farce of

Monsieur Tonson.

Morbleau,	- -	- -		**Mr. TALBOT.**	
Mr. Thompson,	- -	Mr. CUNNINGHAM.	Tip,	- - -	Mr. SWAN.
Tom King,	- -	Mr. BURKE.	Nap,	- - -	Mr. JAMES.
Jack Ardourly,	- -	Mr. SMITH.	Waiter,	- -	Mr. HART.
Rusty,	- -	Mr. CHIPPENDALE.	Bailiff,	- -	Mr. JOHNSTON.
Useful,	- -	Mr. DIGGES.			
Madame Bellegarde,		-		**Mrs T. HILL.**	
Mrs. Thompson,	-	Mrs. JAMES.	Adolphine de Courcy,	-	Miss CURTIS.

Boxes, 4s. 2d.———Upper Boxes, 3s. 4d.———Pit, 2s. 1d.———Gallery, 1s. 3d.———*Half-price at a quarter past 9, to the Upper Boxes, 1s. 8d.—to the Pit, 1s. 3d.——Doors open at Seven, and performance to commence at Half past Seven.*
Tickets to be had of Mr. SMITH, at the Box Office of the Theatre, where places may be taken every day from 11 till 3 o'clock.

Finlay, Printer, Belfast.

Opposite:
Playbill: 1822. Reproduced from line positive and printed by offset lithography in black with a second colour half-tone tint background to indicate the area of the paper.

Theatre Royal, Haymarket.

BENEFIT

IN AID OF THE

Carvers & Gilders Asylum Fund,

On TUESDAY, MAY 11, 1841;

Will be Performed,

Sir EDWARD LYTTON BULWER's Play of The

LADY OF LYONS.

Beauseant, (a rich gentleman of Lyons) Mr. J. WEBSTER,
Glavis, (his friend) Mr. WEBSTER,
Colonel (afterwards General) Damas, Mr. STRICKLAND,
Monsieur Deschappelles, (a Lyonnese Merchant) Mr. G. BENNETT,
Landlord of the Golden Lion, Mr. T. F. MATHEWS, Gasper, Mr. GALLOT,
Capt. Gervais, Mr. HOW, Capt. Dupont, Mr. WORRELL, Maj. Desmoulins, Mr. CAULFIELD,
Claude Melnotte, - - - - Mr. MACREADY,
Madame Deschappelles, Mrs. W. CLIFFORD,
Pauline Deschappelles, Miss HELEN FAUCIT,
Widow Melnotte, Mrs. STANLEY, Janet, Miss GROVE.

After which, the revived Petit Drama, called

SUZANNE.

The incidental Music composed by Mr. T. GERMAN REED.

Colonel Maddison, Mr. H. WALLACK, Mr. Brinsly Bounceby, Mr. WEBSTER,
Simon Swallow, - Mr. OXBERRY,
Suzanne, (an Orphan) Mademoiselle CELESTE,
Mrs. Lignum, Mrs. WOULDS, Sally Swallow, Miss MATTLEY.

To conclude (with Alterations by the Author,) The

LADIES' CLUB!

Mrs. Fitzsmyth, (the Chairwoman) Mrs. STIRLING,
Hon. Mrs. Derby, Miss CHARLES, Mrs. Major Mortar, Miss P. HORTON,
(Who will introduce a New Song, entitled "The FAIRY QUEEN," the words and Music by Mrs. MABERLY,)
Mrs. Bookly, Miss GROVE, Lady Harriet Smart, Mrs. WOULDS,
Mrs. Twankay, Mrs. W. CLIFFORD, Mrs. Eliza Worrell, Miss PARTRIDGE,
Mr. Tiffin Twankay, Mr. T. F. MATHEWS, Hon. Mr. Derby, Mr. F. VINING,
Sir Charles Lavender, Mr. J. WEBSTER, Major Mortar, Mr. STRICKLAND,
Captain Fitzsmyth, Mr. OXBERRY, Mr. Narcissus Bookly, Mr. WORRELL,
Flammer, - - - Mr. DAVID REES,
Fricandeau, Mr. CLARK, Susan, Mrs. F. MATHEWS.

Private Boxes and Places may be taken of the Committee,

Messrs. SEYMOURS, 38, Long Acre
Mr. BROWN, 26, Newman st. Oxford st.
— EAST, 25, York Buildings, New Road
— KENDRICK, 4, Philpot st. Comml. Rd.

Mr. YATES, 7, Charlotte st. Fitzroy square
— BURTON, 25, Northampton st. King's +
— COCKS, 16, Charles st. Manchester sq.
— DUNN, 2, Norfolk st. Middlesex Hospl.

Mr. JENNINGS, 27, Norfolk st. Mid. Hosp.
— LETTUCE, 13, Duke's row, New Road
— CORNELL, 72, Margt. st. Cavendish sq.
— EAMES, 23, Margret st. Cavendish sq.

Mr. LESLIE, SECRETARY 4, Peter Street, St. James's, and Mr SCARNELL, "Duke's Head," Museum Street.

The Committe in returning thanks to their numerous Patrons, Friends, and the Public in general, for the kind support they have received in furthering the object of the Institution; they hope on this and all other occasions to merit the approbation of those who may be inclined to encourage them with their support, to carry into effect the laudable intention of providing for the Aged and Infirm.

Boxes, 5s.—Pit, 3s.—Gallery, 2s.—Upper Gal. 1s.——Second Price at 9 o'Clock—Boxes, 3s.—Pit 2s.—Gallery 1s.—Upper Gal. 6d.

Doors to be open at half-past Six.---Performance to commence at Seven.

[VIVAT REGINA!

J. PHAIR, Printer, 8, Great Peter St. Westminster.

Playbill: 1841. Photographed to show the texture of the paper and printed by offset lithography from a 150-line screen plate.

cartridge paper, they should not 'fluff', that is, that minute particles of the paper should not transfer to the inked offset blanket, and for coated papers, that the coating should likewise not pick off in contact with the damp offset cylinder. Offset chromo paper is specially made both to avoid bits of the coating breaking down, and to take a perfect dot.

Considerable developments have been made with offset cartridge papers that carry a fairly heavy loading, yet retain the essential qualities of cartridge paper, in contrast to art paper. The paper used in this book for the offset sections (e.g. pages 17–32) is just such a paper. Certainly for fine art reproduction, it seems a waste of the virtues of offset lithography to use art paper, particularly if the subjects being reproduced are pastels, watercolours etc (see pages 34 and 35). Letterpress magnesium line blocks will print on almost any surface, though antique papers, which usually have a roughish surface, will make the lines thicken up. The best choice for fine line work and for electros of wood engravings is a parchment-like smooth paper, or a calendered cartridge.

The other processes have their special requirements. Photogravure needs a super-calendered or an imitation art paper, with almost a glazed surface. For collotype, there is a special smooth machine-finished paper, which needs to be evenly and thoroughly sized. It is usually of a creamy colour. Silkscreen, for flat colours, will print on anything, but for half-tone work should be a one-sided chromo, fairly heavily loaded with titanium dioxide.

Faded photograph and copy, original ($5\frac{1}{4}''\times$ $3\frac{3}{8}''$) *c.* 1900. Photographed on fine grain film (Ilford FP 3), acutance type developer (Acutol) under-exposed, over-developed. Reproduced and printed by offset lithography in black and sepia from 150-line screen plates.

6 The photography of three-dimensional objects

The opposition revealed between the photography of a figured flat surface and a three-dimensional object is basic. In the former case one is copying a simple range, either of tones from black to white or of colour from one end of the spectrum to the other. And these ranges of tone or colour can be matched to a degree beyond argument in photographic print or transparency.

The prior problem, however, of establishing the range, of turning reality into two-dimensional picture, atmosphere into substance, is more complex. To the ranges of tone and colour is now added the range of light and shade – which extends the scale at either end by adding a highlight to white and a shadow to black, and a gradation of intensity to every colour.

Of this extended scale there can be no 'correct' rendering. For if white paper must serve as highlight and the blackest tone printable as ultimate shadow the local tones of the subject must be transposed, i.e. white and black objects cannot be literally rendered as such. Not only this but the photographic process itself cannot cope with the extremes represented by highlight and deep shade – only with sections of that range – though by transposition of tones a successful photograph will make it appear to have done so.

Thus to distinguish between a white surface and its highlight, exposure and printing tone must be pitched so that mid-tones are transposed nearer to black; or, at the other end of the scale, nearer to white when a black surface must be separated from its shadow. In the middle range where either the subject or its illumination offer a range that falls short of brilliance or blackness the process can either translate literally or extend the tonal scale by pulling out the ends to black and white at the printing stage. Which of these ranges is adopted will often be decided by the subject. White-glazed ceramics or marble statuary; low-toned low-relief objects; cast-iron or bronze; these would dictate more or less the tonal range to be exploited. Less extreme examples leave choice and involve taste, the key in which a photographer's work is pitched can be characteristic and part of his means of expression.

COLOUR

The monochrome rendering of coloured reality is a convention in itself severe, and the eye submitting to it will further accept much heightening or lowering of the tonal scale without disbelief or a sense of falsification. The introduction of colour, however, contracts this convention considerably and the eye is consequently much less tolerant of the effects of translation.

Light and shade and full colour are ultimately incompatible and no pictorial convention has succeeded in combining chiaroscuro and colour with both working to full capacity.

Pure colour sensations are those obtained through a stained-glass window, where tone is conveyed by lighter or darker colour and not by variations in the intensity of the light source. This intensity may be diminished or increased over the whole area and the eye retains the idea of weaker or stronger colour. But if the attempt is made to relate two widely separated intensities – say a yellow by strong light and a violet by weak – then the sensation of colour relationship will tend to be replaced by one merely of light and dark. The minimum colour sensation felt in a landscape under brilliant sunshine, compared with that experienced under a diffusing cloud or in the reflected light of dawn or dusk should be a familiar impression.

Colour film is adapted to record the total spectrum under one intensity of light, its ideal the stained glass window or the flat coloured surface. But strongly modelled objects, which can only be adequately expressed in light and shade, introduce other scales of intensity – on the side nearest to and that farthest from the source of light. These can be balanced at a point where reasonable modelling is apparently compatible with a colour rather than a light and shade relationship. But colour film, having less tolerance than the eye and less again than monochrome material, will balk at this visual balance and if the exposure has been based on the middle intensity then the other two will be hopelessly bleached and impossibly obscure and totally without colour value.

Variation in lighting intensity must therefore be reduced to a minimum by the use of almost equally opposed lamps or by strong reflected light onto the shadow side, reminding oneself always that the process will strengthen the apparently weak contrasts.

Certain subjects may make it possible to deal with one end or the other of the intensity scale and, by letting either highlight or shadow values go, assist a stronger balance between the other two. Low relief material of any kind, for example, where the small area of cast shadow makes its rendering as black immaterial. Or with any sombre low-reflecting subjects where the equally small area of highlight can be safely ignored.

Compromise is in every case inevitable: the process demands flat lighting, straight on to the object whose plastic nature demands oblique lighting from one side or another. Departure from the demands of the process risks not only

inaccurate but horrifying colour rendering, and from the demands of the object a feeble expression of its form. Surprisingly enough it is frequently possible to achieve a result which gives a fair account of both form and colour, but it must be acknowledged that most colour photography of sculpture can only be considered a mistake.

LIGHTING

Light is crucial and the manner of its use will condition above all else the character of the final image. There are two basic alternatives – direct and indirect – one involves cast shadows the other only degrees of light and shade.

The eye has a misleading love of brightness and contrast and will tend to *bully* in the direction of over-intense direct light. This is not what the medium prefers and the experience of trying to print a contrasty negative is a good corrective.

Unless the subject demands a dramatic treatment all lighting should be gentle and pervasive, producing no reflecting flare and no dead shadows. It will tend in fact towards the condition of diffusion – where the object is allowed to state quietly its own tones and planes. Daylight is superior in pervasive quality to diffused or reflected artificial light, and a white walled room with windows in adjacent or opposite walls and some top light will produce an admirable quality of illumination.

With direct light comes the necessity of deciding its direction. On the assumption that the subject is a work of art, however minor, avoid eccentric angles – particularly light from below. Sensations of revealing a latent drama by dramatic lighting should be regarded with suspicion and re-examined. Obliquely from one side or the other and at a similar angle in the vertical plane makes a good point of departure. Continue by slowly rotating the object and observing the play of light over its surfaces, having achieved an expressive balance of shadow from its vertical edges adjustments can be made to the altitude of the lamp to shorten or lengthen shadows from the horizontals.

A certain lack of plasticity is sometimes felt in the farthest shadowed plane, particularly if the subject is circular in plan. This can be corrected by a weak light used obliquely from the back so that the area of shadow occurs only on the swell of the forms and the receding plane passes into light. This should be done discreetly and resisting the temptation to set up a secondary system of illumination in conflict with the first.

REFLECTORS

The need for secondary illumination to lighten shadows always accompanies direct lighting. This should never be supplied by a second direct source, unless very distant, but either by reflecting back the main light or using a second lamp turned towards a reflecting surface. Reflectors can be of stretched white fabric, white card – matt or shiny, or of metal foil. Unless the latter is roughened or wrinkled it will reflect too powerfully and destroy the point of the device, which is to illumine without casting a subsidiary set of shadows and confusing the simplicity of the lighting scheme.

ANTI-LIGHT

As important as light sources, are means of intercepting and spreading light; boards or shaped cards to cast a partial shade on object or background and relieve one from the other, or to block the reflection of windows or lamps; screens of muslin or tracing paper to spread an intense local light source over a larger area. Highly reflecting objects in particular will be found almost impossible to photograph successfully without the aid of both these devices – shadow boards to cut out reflections and the diffusing screen to give an area, as opposed to a point, of illumination. The exercise being to reduce excessive contrast and minimize the sharp reflection of concentrated light sources – but not to present the object as if it were anything but bright and polished.

All polished metals, jewellery, coins and any small shining objects will need this kind of anti-reflection, anti-highlight treatment to yield a printable negative. With very small objects, say sixpence-size but of more complex shape, it will sometimes be difficult to obtain sufficient separation between object and shadow even with diffused light. A means of clarifying or dispersing the shadow can be contrived by arranging the objects on ground glass, or on tracing or tissue paper spread over a clear glass sheet. This is lit by reflected light from below. If the light is intense the objects will appear to float in space, but if of lower power enough faint shadow from the top light will remain to give a sense of anchorage. There are few things more visually dispiriting than an object photographed on a piece of textureless paper or cloth. This scientific, no-nonsense treatment is usually completed by including a length of inch-rule, in brutal black and white alternates, to restore the lost idea of scale.

Besides conveying a sense of scale the textured ground enables the photographer to produce a print whose every surface tone will 'read'. To be confronted in

fact with any sizeable area of unexposed printing paper in a photograph is to be inexplicably refused information – as baffling as holes in a map. A well contrived photograph will have tone and texture on all but its topmost highlights. Unbleached linen canvas is a good, neutral, basic background material, the scale of its weave being sufficiently familiar to the eye. But opportunity may offer more variety – a well grained table top, a weathered stone slab, even a patch of smooth sand – any surface that has both tone and texture. Ground and background can often be one plane – if the viewpoint is high enough or if the ground linen is swept up behind the subject in one continuous curving plane. This device perhaps makes the least obtrusive kind of background but its nature is rather formless; separating the two planes is stronger, in that it produces a line of demarcation which must be calculated in the composition.

Stretched frames of linen canvas make the most useful background material when the subject is small enough to be contained by them. If in focus they give a unity of texture over the whole picture, if not their principal advantage is that they can be arranged at any angle to the object or the lighting scheme and thus become a means of varying light and shade. What might be termed the 'classic' lighting scheme for a regularly shaped object is for its lights to be relieved against shade and its shadows against light, and this deceptively simple arrangement is often most difficult to achieve unless the background can be so angled as to receive a gradated light. In this respect also shadow boards will be found useful.

With sufficient distance behind the subject it is possible to dispense with a material background. Space or a distant wall then form the back plane and its tone can be controlled by shading the main illumination. Such a background is almost inevitable when the subject is too large to be contained within the boundaries of a portable screen. If space is not available and the area to be covered is beyond the scope of stretched fabric any loosely hung piece of stuff, however creased or stained, may be made to give the effect of an atmospheric background if it is kept constantly in motion during a time exposure.

OUTDOOR SCULPTURE AND CHURCH MONUMENTS

The photography of immovable sculpture in the open presents the photographer with a number of factors that are beyond control – and brilliant success is often the result of being in the right place at the right time and, not least, of having the talent to recognize good fortune. Nowhere is this more certain than in the

matter of lighting. Only a native of the neighbourhood or a stranger with much time to spare can anticipate the effect of a certain angle of sunlight and wait for the hour or day when the effect is realized. In view of the uncertainty of weather this uncompromising attitude involves frustrations and irritations which end in reducing the photographer's visual sensibility, and the more creative approach and ultimately the most rewarding is to exploit what the moment offers.

Apart from the rare fortune of finding the subject illuminated from the right angle with regard both to viewpoint and background a brilliantly sunny day is the least propitious since it inhibits all but one or two points of view. Mixed sun and cloud is better if the clouds are either large or slow enough to allow the observation of an effect or viewpoint, and time to consider and record it. But only a day of generally diffused light will give independence and the freedom to exploit every possibility. As noted elsewhere in the text this quality of light is photographically very lucid and with the appropriate technique capable of much more contrast and pictorial effect than is apparent to the eye.

Such light is highly actinic and its one severe drawback is the impossibility of reducing a diffused sky to a darker tone – no filter will restrain it enough to allow marble statuary to be shown in clear relief against it. Fortunately many monuments are sited with this disadvantage apparently in mind and use can be made of the foliage of tree and hedge screens or the walls of adjacent buildings.

The adjusting of viewpoint and angle, not only to obtain a characteristic and expressive image of the subject but so that it relates plastically to its background and is well relieved against it, is the essential task. Luck of light and shade will help and the habit of regarding the immediate surroundings not so much as substance than as patches of tone – to which they can be turned by selective focusing. Distant viewpoints with a long-focus lens make the maximum use of nearby buildings and trees, which, unless they are very close, tend slowly to subside below base level as one approaches the subject.

Distracting and utterly non-contributing background incidents can be subdued by arranging that they are not in focus. This is easily achieved with any lens that is longer in focal length than is normal for the camera. With the normal lens it can only be done when working at close quarters or by using the depth of focus principle – i.e. focusing the lens on a point nearer than the object and using an aperture that will just bring it sharp. But unless there is a good distance between subject and background the separation so attempted will not be marked enough.

If selective focusing is used for its own sake, and not to minimize an unavoidable disadvantage, there are points to avoid – literally. An out of focus area should be soft and broad, small broken areas of highlight and shade so treated will be more obtrusive than they were when sharp. Foliage for example, particularly the small leaves of cut hedging, unless in total shade, is a distracting muddle when out of focus. Sharp, its texture relates beautifully with weathered stone.

The coloured image on the focusing-screen prompts many errors of focusing. Colour in fact seems more brilliant and saturated when separated from the idea of strict form and sharp edge and this will often mislead the eye in judging effects of varying focus for a monochrome end. Consequently, when working in colour, there is in this one respect at least more licence. Otherwise there are the cramping limitations described earlier: near frontal lighting, standard exposure time and the colour temperature of bright sunshine.

Absolute accuracy of colour rendering, however, for which these strict conditions exist, can often be relaxed for the kind of subject under discussion. Indeed if it could not, the process would be barely usable – the universe not being susceptible of such control as the workroom, or the sun as a pair of standard lamps. The direction of freedom in this respect is increase of exposure to compensate for the use of other directions or qualities of light.

The photography of effigies and monuments in cathedrals and churches, even more than open air sculpture, is a matter of dealing sensitively with whatever opportunity offers. Electric light is usually available and if permission and co-operation is given for the use of portable lights the problems are parallel to those dealt with earlier in this chapter. A great part of the magic of church monuments, however, is the total ambience of setting and given lighting. To intrude more than the minimum apparatus is not only to unsettle a mood and to dispel a magic but often to create more problems than can be solved. Not for the first time in these pages it is pointed out that providing the conditions of light do not exceed a modest range of contrast, however dimly a subject is lit, it can by well judged exposure and the relationship of that exposure to processing technique, be made to yield a bright image on the final print.

The exclusion of any actual window, unless of the densest stained glass, from the picture field, and the preventing of any light from windows forward of the camera reflecting on the lens are basic essentials. Failure to do this will result, even with a bloomed lens, in a general veiling of the shadow areas and a fogged negative lacking essential contrast. (*Continued on page 132.*)

Detail of a leaf from a 14th century Antiphoner. Taken with two 500 watt lamps, both placed the same side of the subject, to preserve the texture of the vellum. A standard exposure was used. Reproduced from a colour transparency and printed by letter-press from four 150-line screen half-tone plates.

Victoria and Albert Museum.

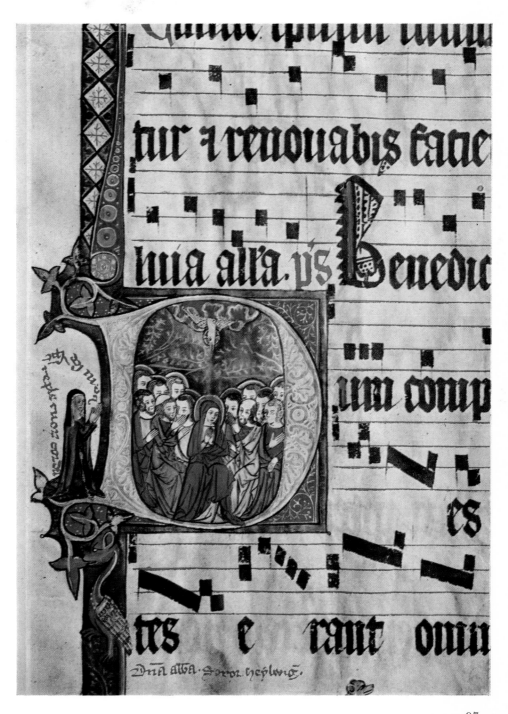

Beadwork *immortelles*: French 20th century. Taken under one 500 watt lamp and one reflector. The background was several feet distant and shaded to relieve light and shade of the subject.

Baby's lace boots: English, 19th century. The grey velvet background was swept up to make a continuous background.

Collection Louis Meier, Cecil Court, London.

All the monochrome examples as far as page 128 are printed by letterpress from single 150-line screen half-tone plates.

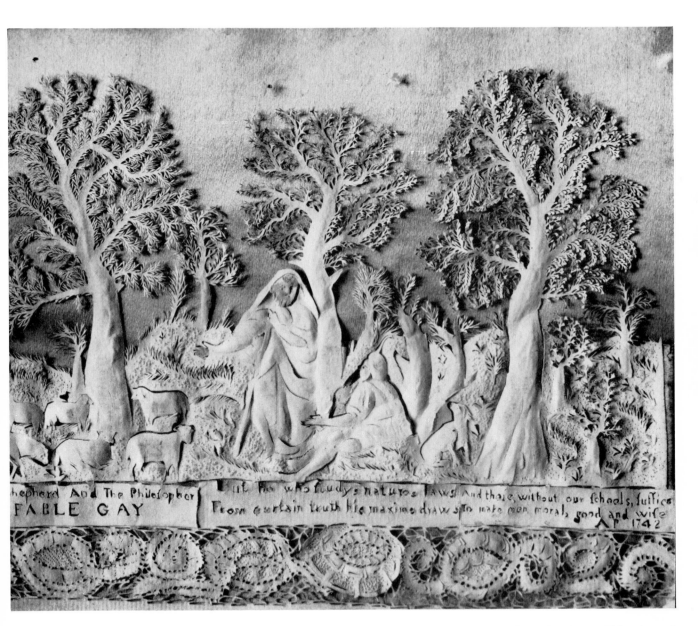

Paper Picture (cut and pinprick technique) by Miss A. Parminter, dated 1742. Taken in weak diffused daylight with slow orthochromatic film.

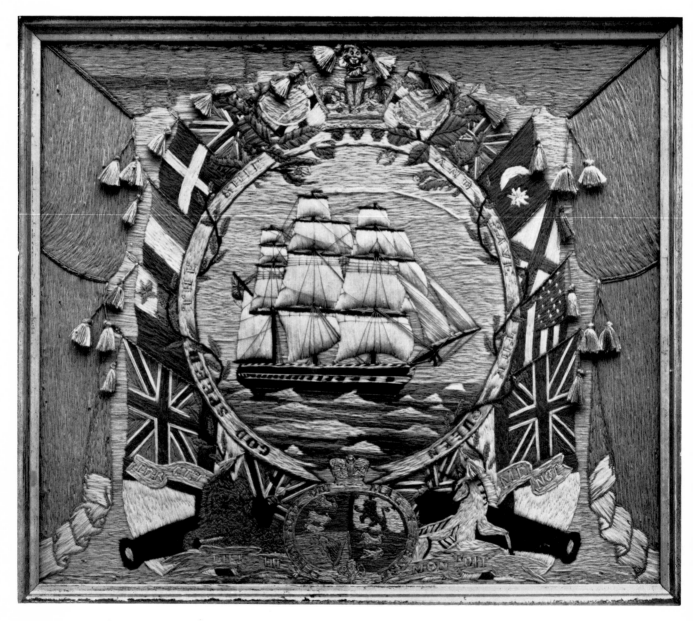

Victorian embroidered wool picture. Diffused daylight gives bland, even, definition. Exposure made, apparently and thoughtlessly, without a filter so that the blues, in the Union Jacks for example, equal in tone the reds.
Collection, the Lady Christina Gathorne-Hardy.

Appliqué felt picture (half and full relief): *c.* 30″ across. English 19th century. Taken with two 500 watt lamps evenly disposed. Reproduced from four colour separation negatives, with a guide transparency on Dufaycolour. Reproduced from four 150-line screen half-tone plates and printed by letterpress.

Collection: Originally John Fothergill, present owner unknown

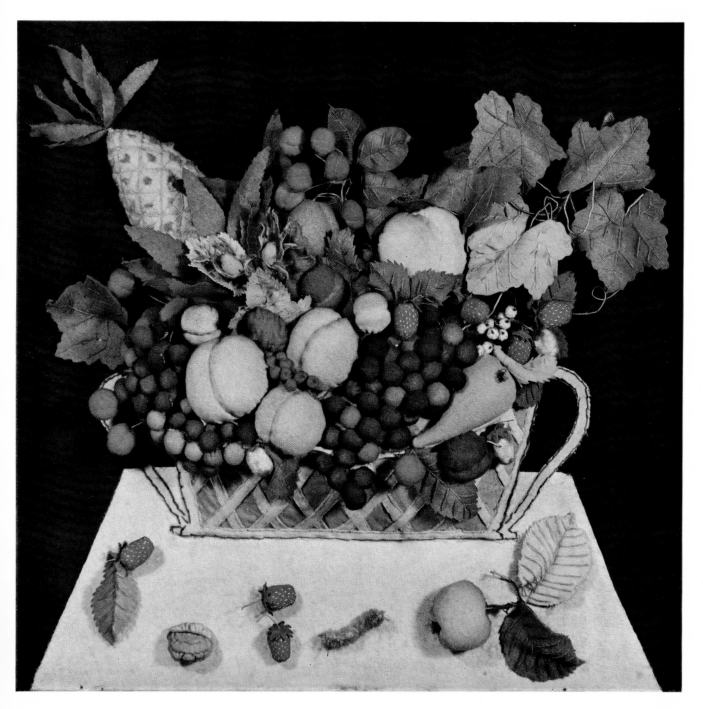

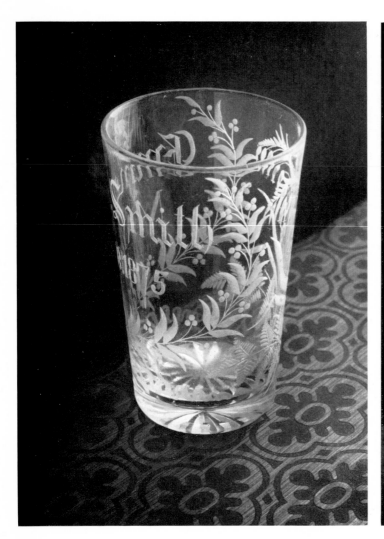 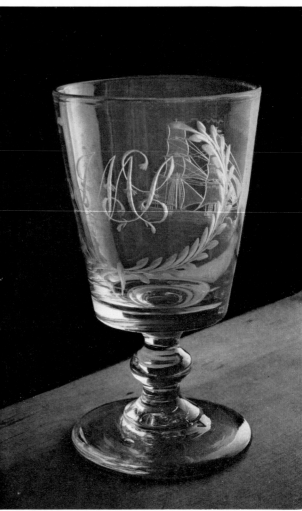

Two English engraved glass tumblers: the one on the left dated 1875, the other *c.* 1850, showing on the reverse a collier brig. Taken with one 500 watt lamp placed obliquely back right. The apparent black background is actually matt white card in deep shade. The use of black material is rarely necessary; it is preferable to create tone by light rather than by local colour.

Opposite:
Composition on an amatory theme for *The Saturday Book*. Taken with one 500 watt lamp, diffused and placed rather low to model the shallow relief of the cameos and highlight the jewellery. One low wattage light was placed above, whose reflection in the polished wood background is made to coincide with the wedding ring.
Courtesy Hutchinson and Company: Jewellery from *Cameo Corner*.

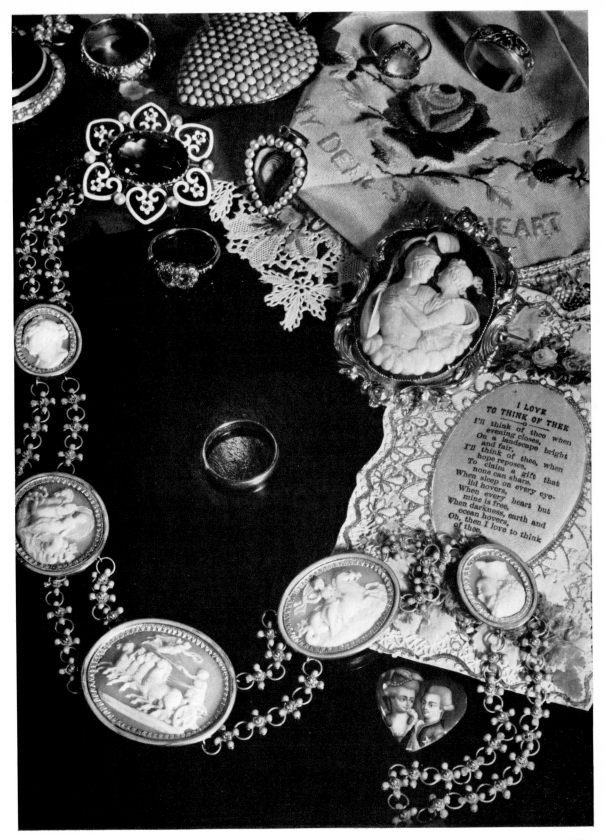

I LOVE
TO THINK OF THEE

I'll think of thee when
evening closes,
On a landscape bright
and fair,
I'll think of thee, when
hope reposes,
To claim a gift that
none can share.
When sleep on every eye-
lid hovers,
When every heart but
mine is free,
When darkness, earth and
ocean hovers,
Oh, then I love to think
of thee.

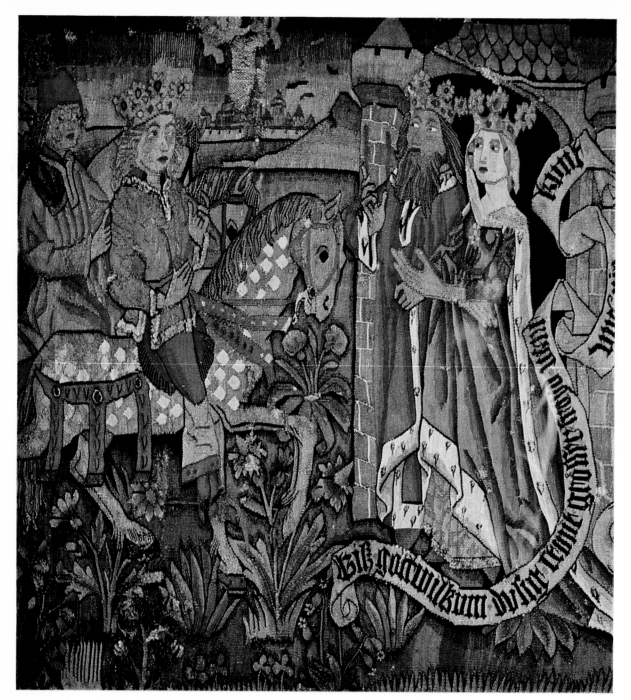

The Buzzard: detail from a South German tapestry, second half of the 15th century. The original was under glass, creating complex reflections. Two 500 watt lamps were placed on the same side, but the exposure was divided and the lamps were moved to the other side, further away for the second half. Reproduced from a colour transparency and printed by letterpress from 150-line half-tone plates in four colours.

Opposite:
Tapestry (Brussels?) in Mary Queen of Scots room, Hardwick Hall, Derbyshire. Existing diffused daylight from one side. Not the recommended lighting-scheme for tapestry, but here a cross light falling on a stitched and dimpled surface seemed to assist the artist's intention of conveying the glitter and complexity of foliage.

105

page 108. 15th century stained glass window at All Saints, Icklingham, Suffolk. Taken at 10 a.m. in October. Weak sunshine from the east (shining on the right-hand of the spandrel) has given illumination without glare, even through the areas of clear glass. A long-focus lens was used. Reproduced from a 9 × 12 cm transparency and printed by letterpress from four 150-line screen half-tone plates.

page 109. Festival costume from Attica: 19th century. Taken with one 500 watt lamp, as exhibited in a museum gallery, with no control over the background; but advantage was taken of a half-open door to create an area of shadow. Reproduced from a colour transparency and printed by letterpress in four colours from four 150-line screen half-tone plates.
Benaki Museum. Athens.

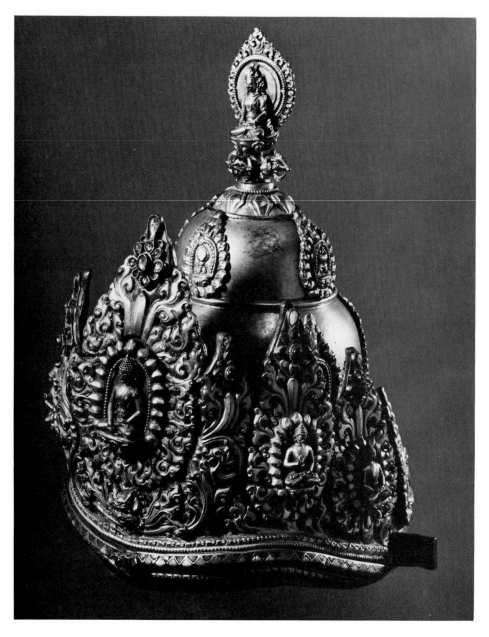

Opposite:
Mechanical toy in a glass case: English 19th century. Taken in weak diffused daylight with slow panchromatic film.
Courtesy Stourhead House, Wiltshire.

Tibetan ritual headdress. Taken with two 500 watt lamps placed at unequal distances. The exposure was made at an exhibition, with no control over the background.
Victoria and Albert Museum. (Courtesy Elek Books)

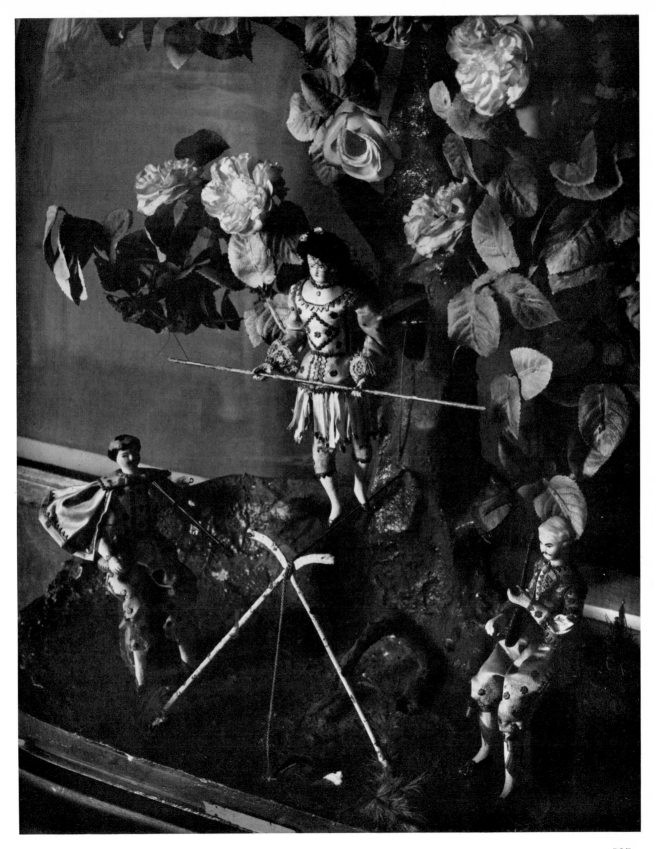

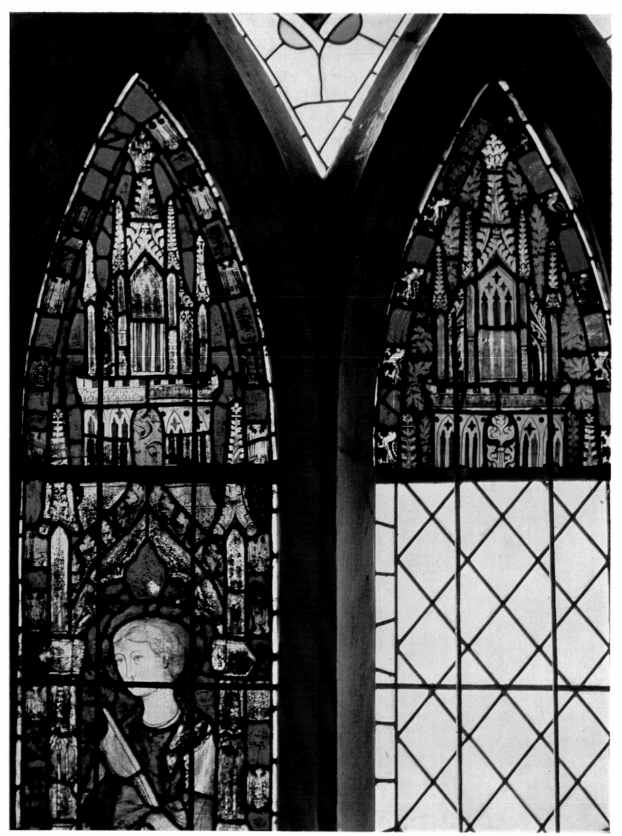

For captions see page 106

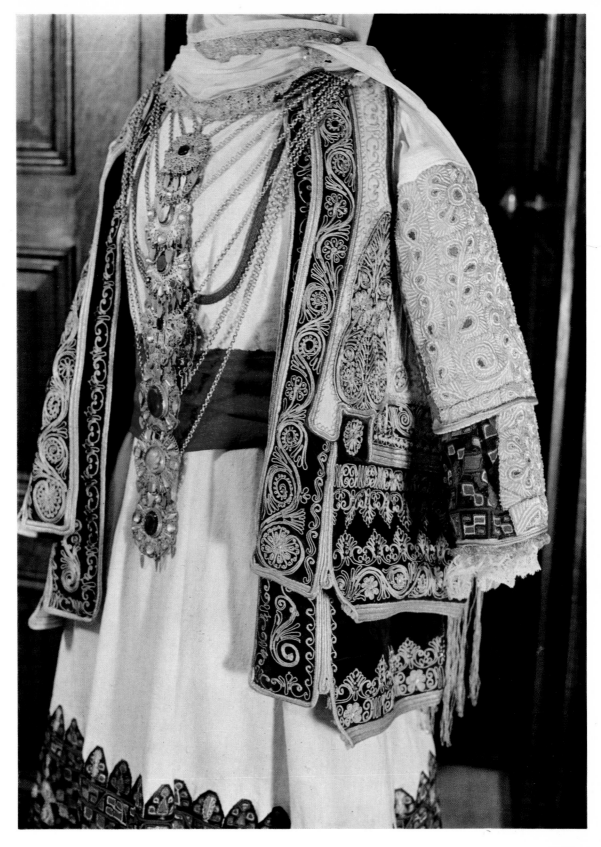

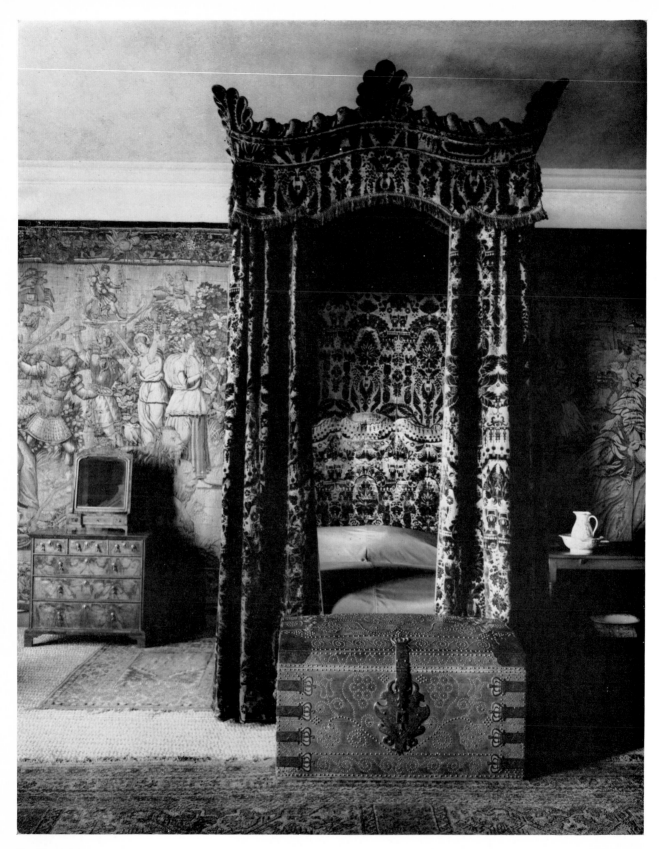

For captions see page 113

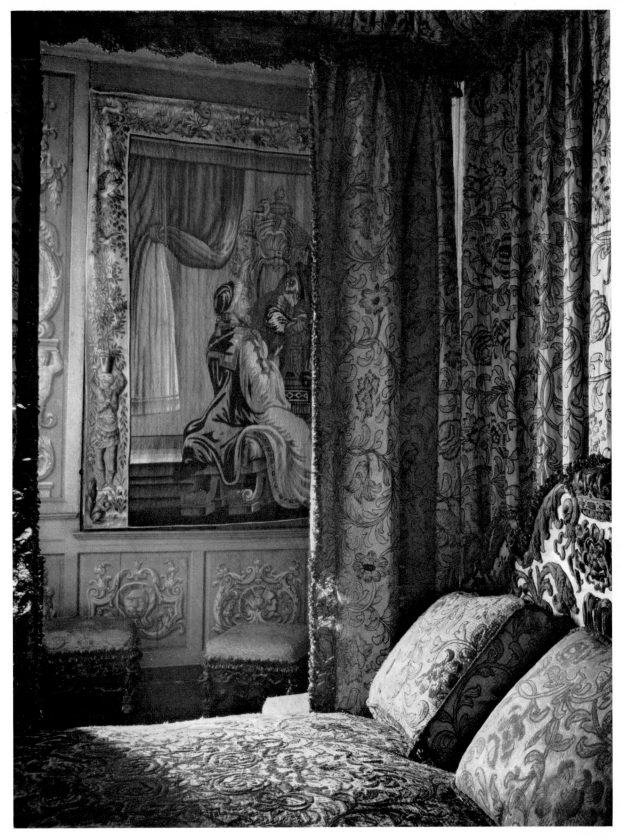

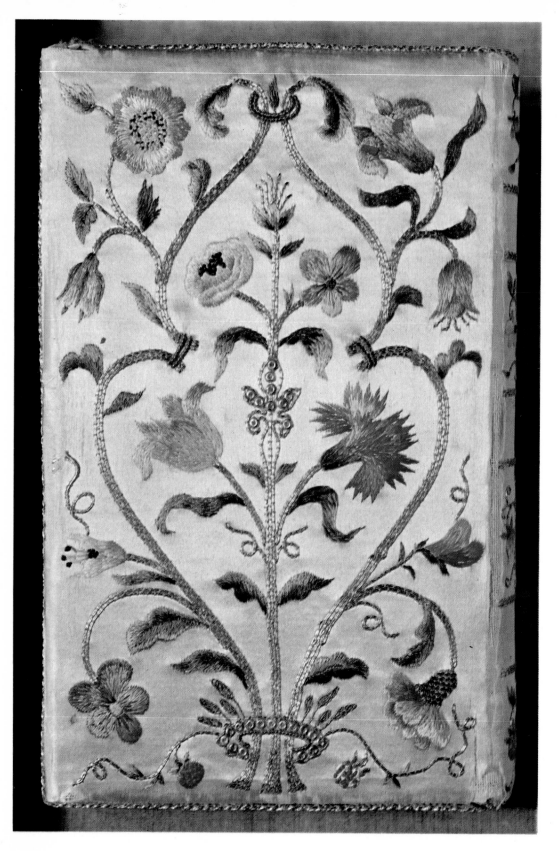

page 110. The Green Velvet Room, Hardwick Hall, Derbyshire: the bed-hangings *c.* 1720 and the Brussels tapestry late 16th century. Taken in existing daylight, a side light with strong contrasts. The negative was over-exposed and under-developed to retain as much over-all detail as possible. The reverse treatment to the next example.

page 111. The King's Bedroom, Knole, Kent. The bed has gold and silver embroidery and in the background there is a 17th century Mortlake tapestry. Taken in existing daylight with a reflector used to show detail in the shade of the bed-hangings. A fast panchromatic film was used. The subject was very weak in contrast.

Opposite:
English embroidered book cover for *Imitation of Christ* (9″ × 5½″) signed 'E B S' and dated 1886. Taken with one 500 watt lamp. Standard exposure time. Reproduced from a colour transparency and printed by letterpress from four 150-line screen halftone plates.
Courtesy: Sun Inn Antiques, Saffron Walden.

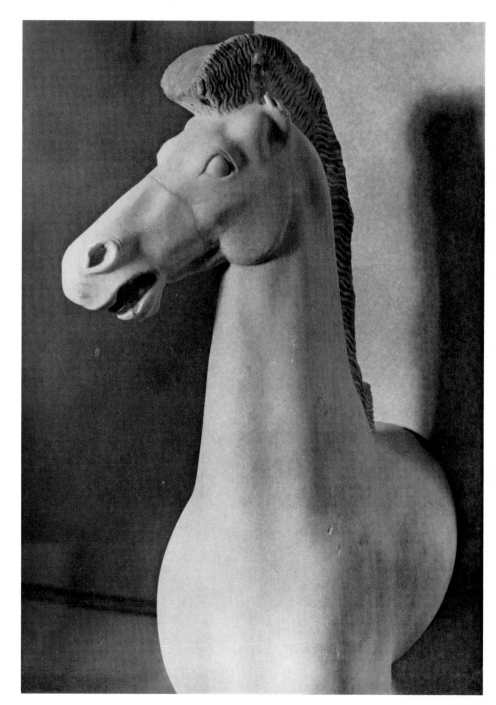

Greek Marble Horse: 5th century B.C. 46″ high. Taken in existing brilliant daylight. The viewpoint was chosen to take advantage of an area of shade to the left of the subject.
Akropolis Museum. Athens

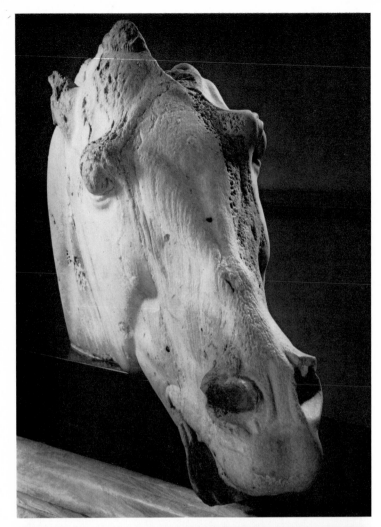

Elgin Marbles, British Museum: the head of a horse from the east pediment of the Parthenon, 432 B.C. Length 33″. Taken with two 500 watt lamps but with the general early morning daylight in the museum gallery.

Front view: main light from the left, second lamp at the rear and to the right, giving an area of light shade on the planes facing the camera. (Courtesy Elek Books Ltd).

Profile: main light from the right, but a more distant and much more oblique light to the left to relieve mane from the background. (Courtesy Thames and Hudson Ltd).

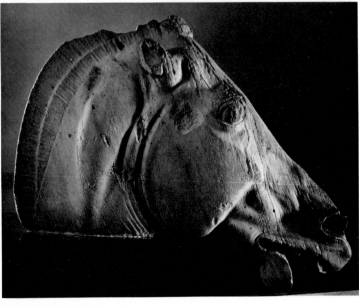

Opposite:
Groom leading a horse: Assyrian 7th century B.C. low relief limestone carving. Height 5′ 3″. Taken with one 500 watt lamp at a distance of about 15 feet; the subject illuminated consistently but weakly. Contrast was introduced by the use of a slow film and slight forcing of development. This has also emphasized the irregularities of colour in the limestone, which are much less evident in the original.
British Museum (courtesy Thames and Hudson Ltd).

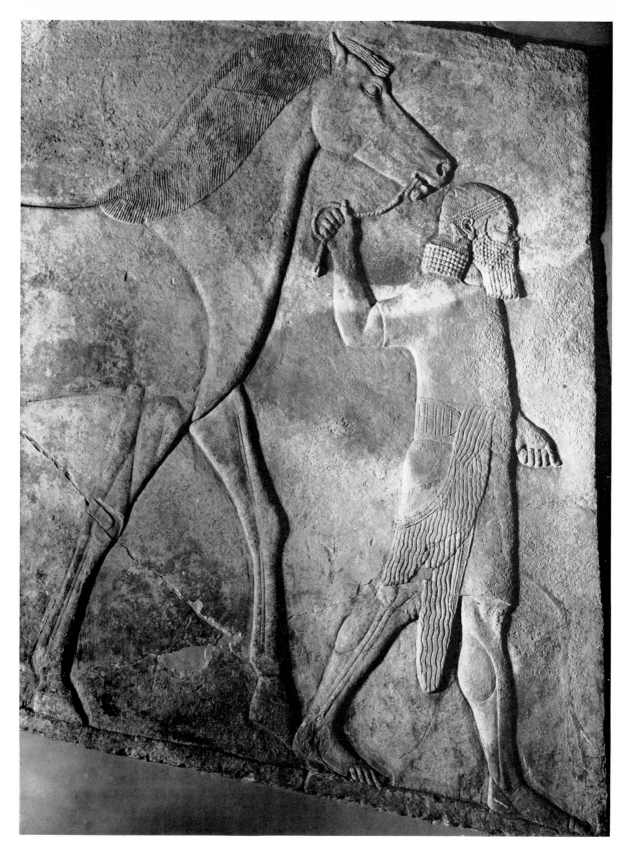

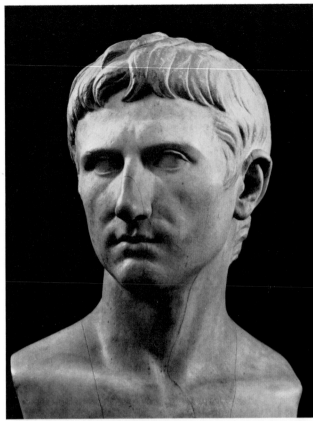

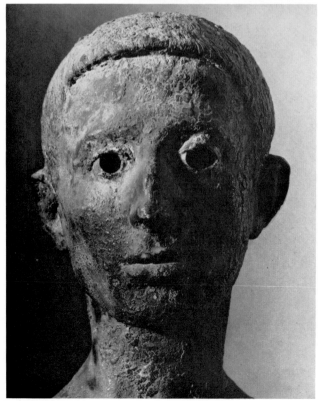

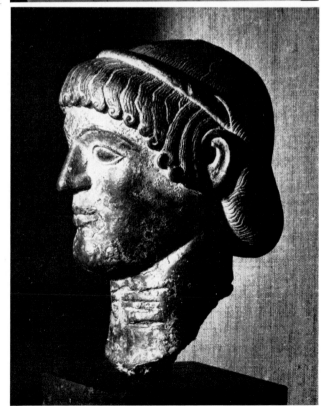

Opposite right:
Roman marble bust: the Emperor Augustus (63 B.C.–A.D.14).
Taken in diffused daylight in a top-lit studio. The background
was shadowed space.
British Museum (courtesy Thames and Hudson Ltd).

Opposite left:
Roman marble fragment: the Emperor Claudius as a young
man. Taken with two 500 watt lamps placed at unequal dis-
tances from either side to create an area of shade on the front
planes and minimize the effect of the damaged nose. The rim of
shadow cast from the left helps to detach subject from back-
ground. The picture was made originally for newsprint repro-
duction by coarse screen half-tone.
British Museum.

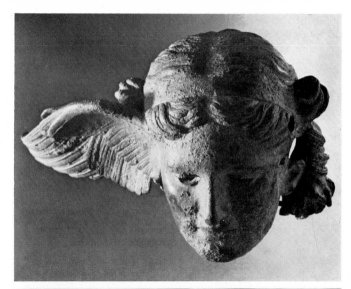

Opposite left:
Life-sized bronze bust of Marcello from Pompeii. Taken with
one 500 watt lamp at the top left and daylight in the museum
gallery.
Naples National Museum.

Opposite right:
Small bronze Etruscan head. Fifth century B.C. 6″ high. Taken
with one 500 watt lamp on level with the subject from the
direction it faces. The background of stretched linen is in focus
to enhance the sensation of texture set by the subject.
British Museum (courtesy Thames and Hudson Ltd).

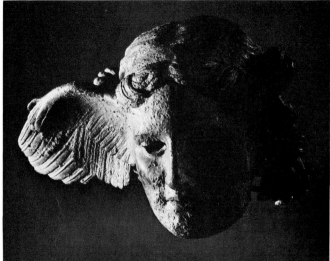

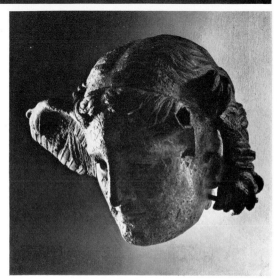

Greek bronze head of Hypnos: 450–300 B.C. Height 8″. Taken
with two 500 watt lamps combined with existing early morning
daylight in the public gallery of the museum. The object is
exhibited in a case whose angles controlled the viewpoint and
the position of the lights. The main light was established at
object level, from the left, for all three exposures. In one case
the shadow side was illuminated with a reflector, for the others
a second lamp was used at a considerable distance and the exist-
ing background shaded to give a counter change of tones.
British Museum (courtesy Thames and Hudson Ltd for lower picture).

Wrought iron screen with gilding by Robert Bakewell (*d.* 1752) in Derby Cathedral. Taken in existing daylight, the viewpoint arranged to catch reflected light from the south windows of the nave on the gilding. A long-focus lens (subject high), fast panchromatic film and a soft-working developer were used. (Subject contrasts high.)

page 120. The Vernon Tombs, Tong Church, Shropshire. In the foreground, the figure of Sir Richard Vernon of Haddon Hall (*d.* 1451). Existing light of midday in August from an east facing window. The camera level was contrived to get the accumulative effect of a packed Chantry Chapel. The photographer's diffused shadow at the lower right was used to give lighting variety.

page 121. Sir Thomas and Lady Lucy: Charlecote Church, Warwickshire. He by John Schoenman, she by Thomas Burman. Taken in existing weak daylight at 11 a.m. in November. The shadow from a supporting column gave rich modelling to the lower figure, but was lightened by a reflection from white paper on the upper figure during a 4½ minute exposure (*f*32) on slow panchromatic film.

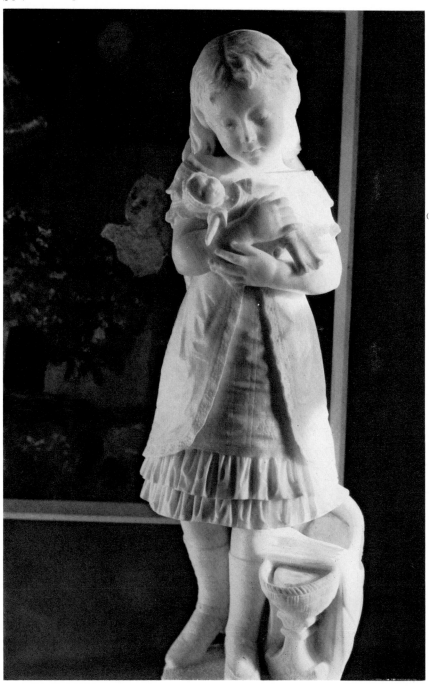

Victorian marble figure: Child with Dutch doll by Bienaimé. Height 35″. Taken with direct winter sunlight from a window about 12 feet to the right and the reflected light from a white door about 6 feet to the left. The combination of picture and sculpture was unarranged, but seen to be right, as, of course was the whole effect which lasted only long enough to set up the camera and make an exposure.

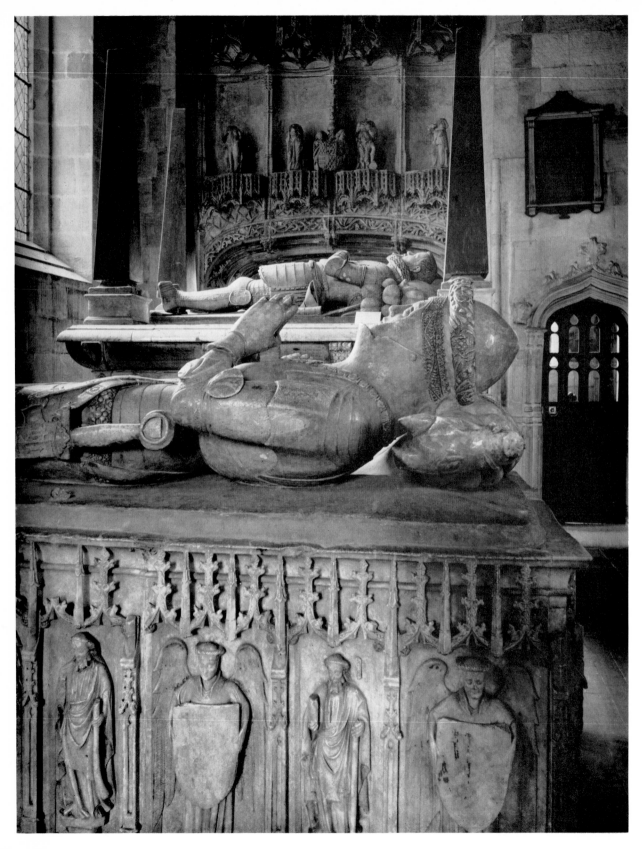

French 14th century ivory: Virgin and Child. Taken in the museum studio with strong general daylight, one 500 watt lamp and a reflector. The background and base-cloth were shaded. A white card and one reflector near to right-hand side. A long-focus lens used, the small depth of focus is revealed by the linen texture of the base plane.
British Museum.

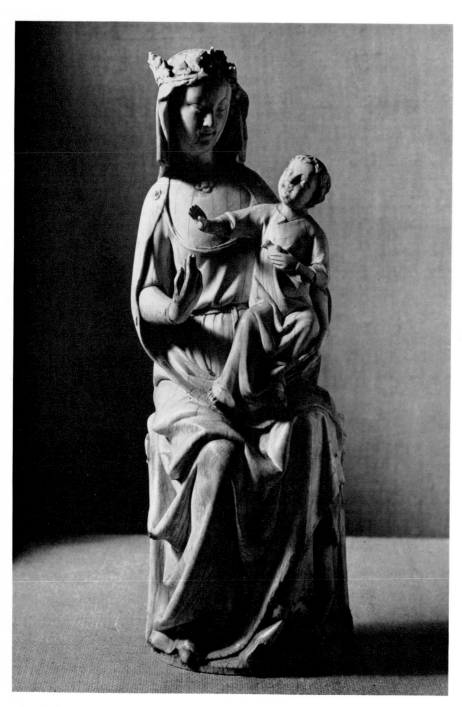

Fukien porcelain figure of Kwan Yin. 15½″ high. Taken with one 500 watt lamp and reflector, used in the basic fashion – at 45° to the object in the horizontal and vertical plane. Base and background were shadowed. A fast panchromatic emulsion was used for low contrast and a soft-working developer to keep it.
Victoria and Albert Museum.

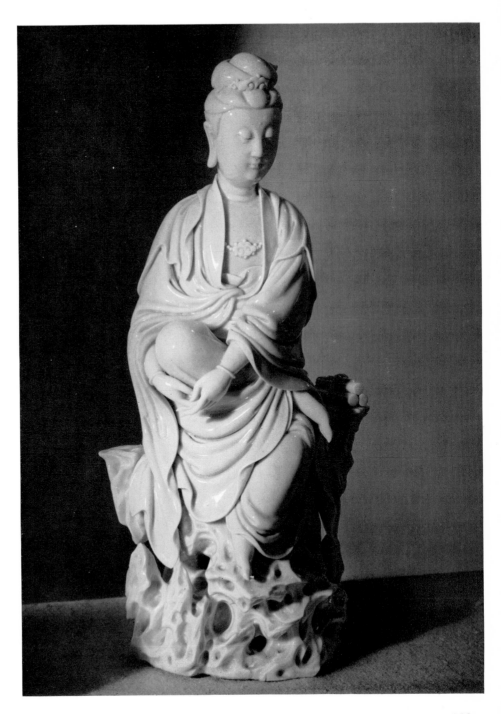

Basalt figure: the Aztec Flower Prince Xochipilli, 14th–15th century. 21¾″ high. Taken in the museum studio, with a strong north top light and one 500 watt lamp. The stretched linen background is in focus to keep a feeling of texture throughout the print. The background is partly shaded to emphasize the head.

British Museum (courtesy Thames and Hudson Ltd.)

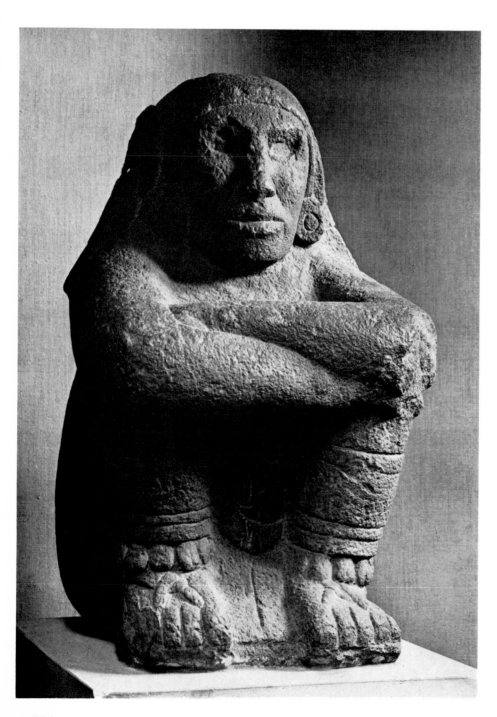

Black syenite figure: the Egyptian Court Official Sennefer *c.* 1500 B.C. 33″ high. Taken with two 500 watt lamps and existing morning light in a public gallery of the museum. Black and highly reflecting – a photographically horrible combination, but an attempt was made to benefit from the latter disadvantage by reflecting the main light off the plane broken by hieroglyphs. The secondary light, off a reflector, was distant but just enough to catch the edges of the right-hand plane and highlight the thigh. The background space was beyond control but shaded from lamps.

British Museum (courtesy Thames and Hudson Ltd.)

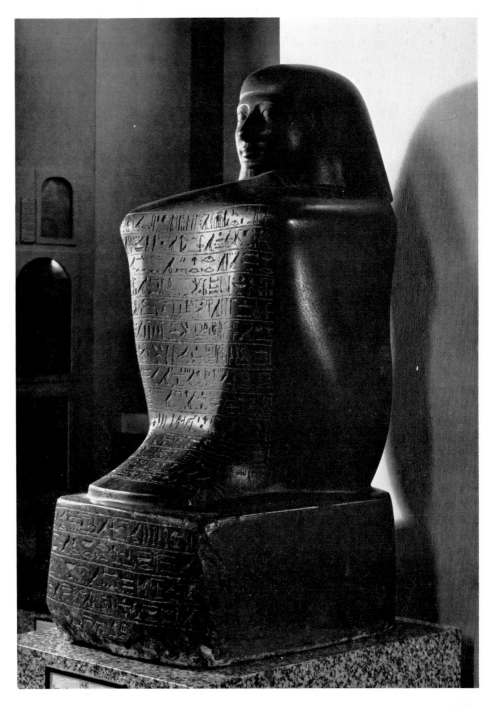

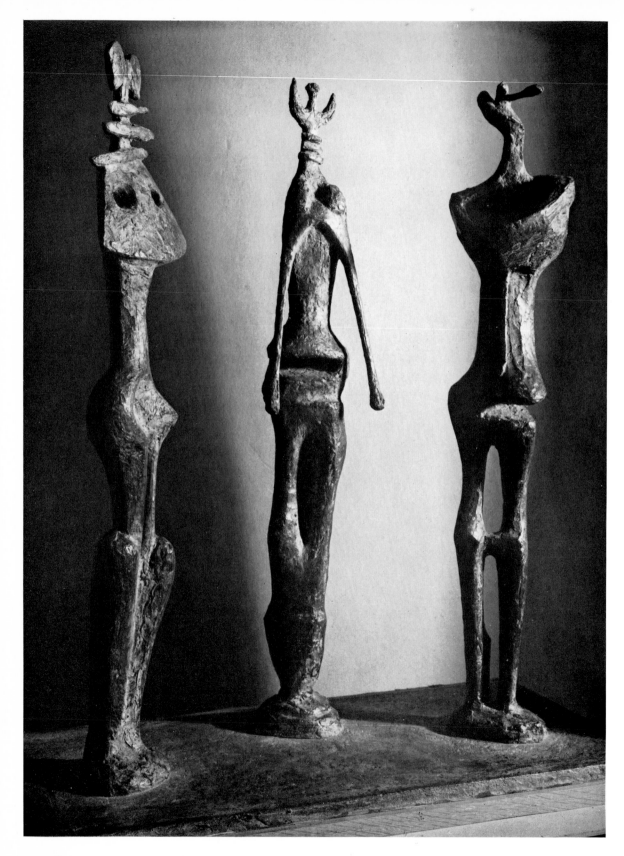

Opposite:

Three Standing Figures, bronze, by Henry Moore (1952). Taken with one 500 watt lamp. The background shade was cast by arranged boards to give variety of tone contrast.
Courtesy Arts Council of Great Britain.

Bronze object by Eduardo Paolozzi. 18″ × 11″. Taken in faint December sunlight after a heavy frost which has coated the object, accentuating its modelling, surface textures and mood. A long-focus lens was used to put the background out of focus. A slow emulsion and Acutance-type developer, to sharpen contrasts.

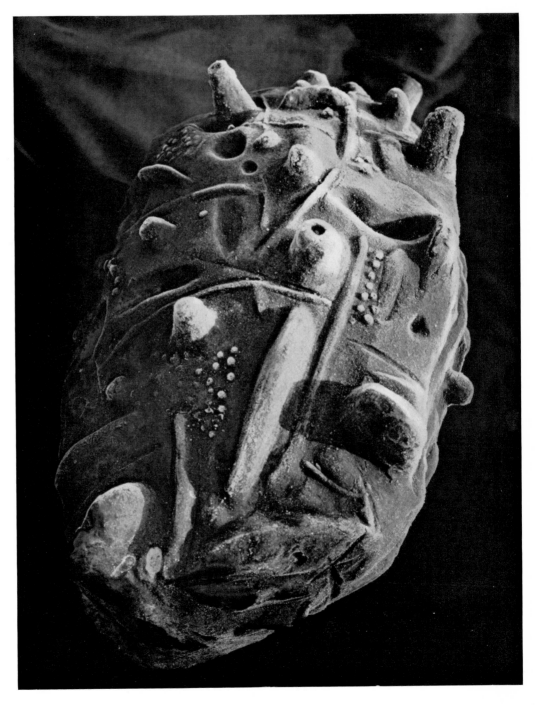

Painted oak effigy of Edmund Cornwall (*d.* 1508) in Burford Church, Shropshire. Taken in existing weak daylight at 6.30 p.m. in April. The camera was set up over the legs of the effigy, sighted blind and focused by distance estimation and exposed with a long cable release. All on the assumption that the Victorian tessellated floor would complement the slightly Frankenstein simplicity of the figure. A wide-angle lens was used.

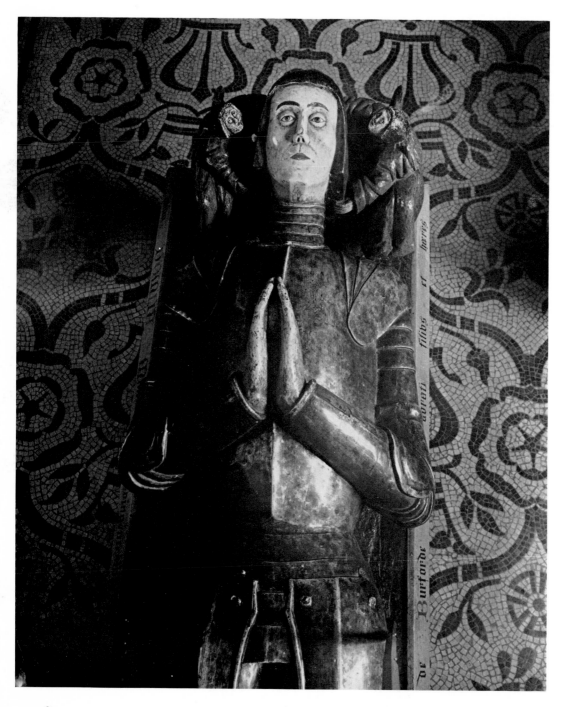

Terminal statue on the Tagus Bridge, Aranjuez, Spain. Photographed at 11.0 a.m. on a sunny April morning. Panchromatic film (HP3) × 2 yellow filter, hand camera, negative 9 × 6 centimetres. Reproduced and printed by offset lithography from two 150-line plates. Note: To get a richness comparable to the above, when printing by offset, it is essential to use two printings. The screens of each plate are at different angles.

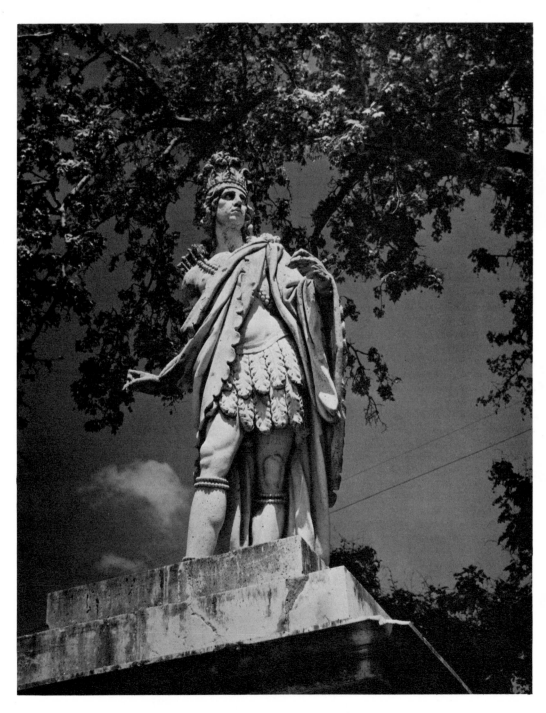

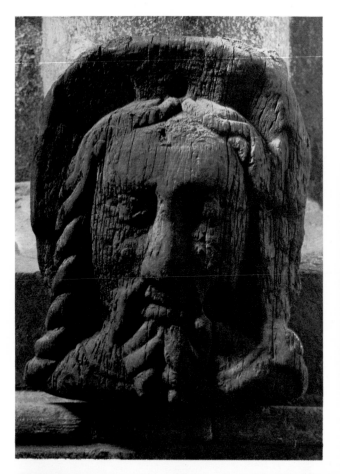

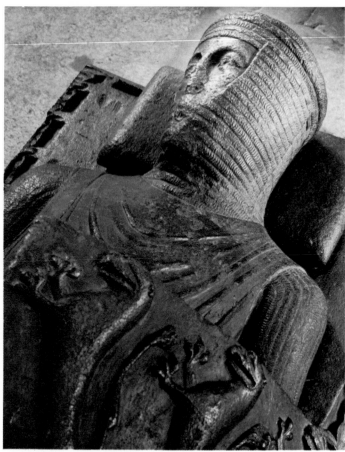

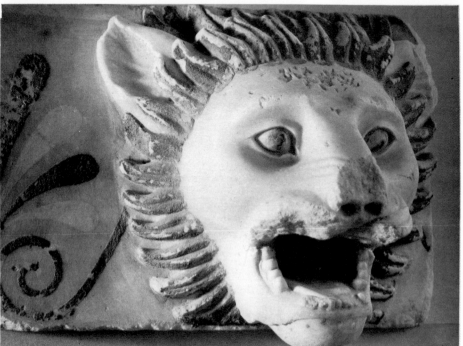

William Longespee Monument, Salisbury Cathedral. Thirteenth century blackened and polished wood carving. Photographed on a panchromatic plate under existing daylight. Negative 9 × 12 centimetres. Soft working developer.

Top left:
Roof Boss, Selby Abbey, Yorks. Fourteenth century charred wood-carving. Matt surface. Photographed in the diffused daylight of the inside of the church on orthochromatic emulsion. Negative size 9 × 12 centimetres.

Waterspout, Akropolis Museum, Athens. Fifth century B.C. White marble partly painted. Photographed under brilliant daylight on a negative 9 × 6 centimetres.

All the above have been reproduced and printed by offset lithography from two 150-line screen plates.

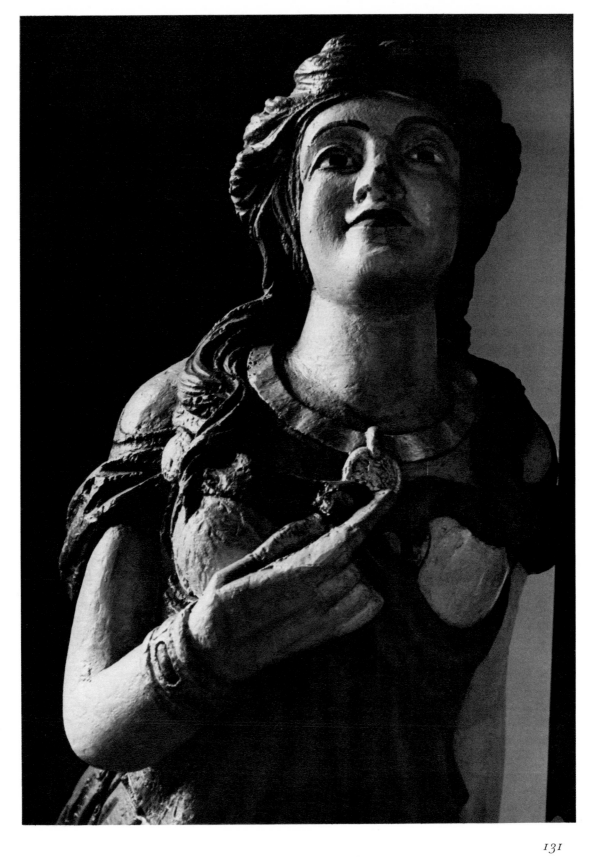

In a building with windows on all four sides and frequently a clerestory above, there are often too many sources of light. This can make for confusion in modelling and a flattening of low-relief sculpture. An intercepting hand or book will be enough to confirm the presence of an unwanted light source, and for the exposure, if the subject is not too high, it is often enough merely to stand in the offending direction. During an exposure, which may vary between half a minute and five minutes, modifications of this kind will help even if carried out for only part of the time. At the same time light can be reflected into densely shaded areas with any improvised reflector – from a handkerchief to an open prayer book – moving the reflected light over the subject. In this way, by partial shading and partial reflection, one can literally draw in light.

Particularly difficult are wall monuments set closely between two bright windows. Working from the centre of the church with a long focus lens will often enable one window to be obstructed by a pier, the other can be masked by black paper attached to a lens hood, though if the window is very close to the subject enough light tends to creep round the mask to fog that side of the negative. Waiting till dusk and using artificial light may sometimes be the only solution.

Last and worst are the small wood-carvings known as misericords found on the undersides of many choir stalls and revealed by turning up the seat. Here both working space and natural light source is restricted by the front of the stall. Space, as little as two feet, will rarely permit the use of a back focusing screen even with a wide-angle lens so the camera must be pre-focused at the measured distance and set up blind. Bog-blackened by time but with highlights brilliantly polished by an infinity of churchwardens' and choir-boys' seats, these enchanting subjects represent the ultimate, in the technical sense, of the non-photogenic.

The technique of spreading the source of light is the best hope of success. If enough natural light is available this can be reflected up on to the carving; if artificial light is obtainable a low-powered bulb reflected off a white surface, or, if not, an 'open flash' with the flash bulb dimmed and diffused by translucent polythene or muslin. Whatever means is chosen it will usually be necessary to repeat it on either side of the subject. The effect intended is light spread across the surfaces, so that the eventual image is not black with dot and streak highlights – but an articulated middle tone with shadowed extremities.

Full exposure and under development may still produce a contrasty negative difficult to print. Misericords *in situ* should be the diploma-piece of the photographer of objects.

Previous page:
Ship's Figurehead. Nineteenth century. National Maritime Museum, Portsmouth. Over life-sized painted wood carving. Photographed in existing daylight with strong side light from adjacent window on a negative 9 × 12 centimetres.

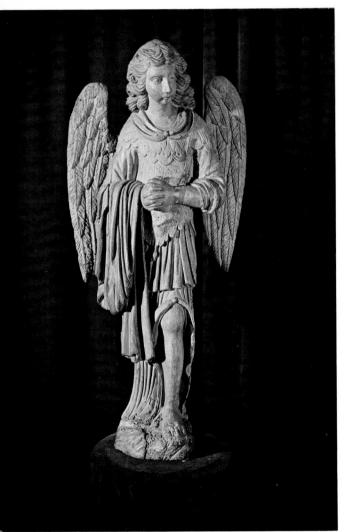 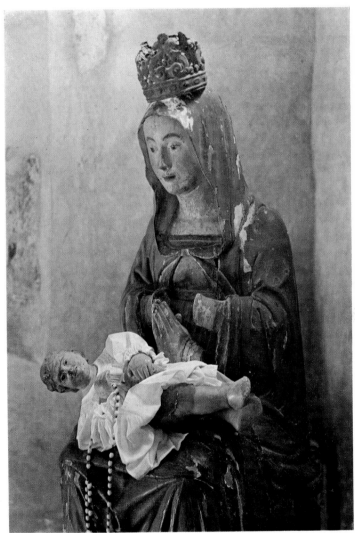

Polychrome carved wood statue of St. Michael, East Anglian, *c.* 1500. Photographed against dark green velvet curtains. Two kilowatt spotlights were placed to one side and a 500 watt fill-in light was used on the opposite side. Reproduced from 5″ × 4″ Ektachrome, type B.
Courtesy Blair Hughes-Stanton: photograph Bob Alcock.

Painted wood Madonna and Child from San Zeno, Bardolino, Italy. Taken in existing brilliant but diffused daylight. Artificial light Ektachrome was used with an orange correcting filter and a five second exposure. The colour is atmospherically accurate.

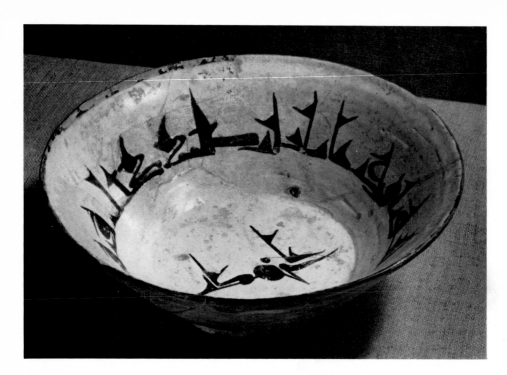

Persian slip-ware bowl 9th–10th century from Samarkand. Dia. 7⅜″. Taken under one 500 watt lamp used above and slightly to one side of the object.
British Museum.
(Courtesy Thames and Hudson Ltd)

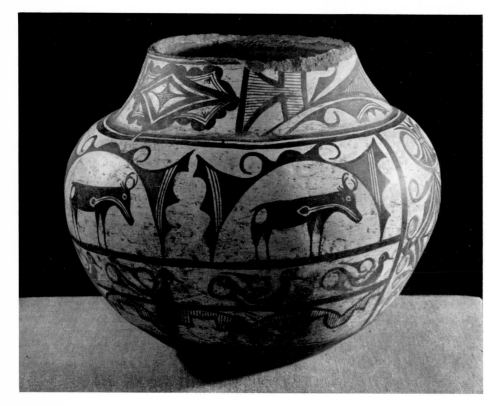

Pueblo water jar from New Mexico: 20th century. Height 10″. Taken with two 500 watt lamps placed at unequal distances but both used obliquely from the rear so that the plane nearest the camera swells into shade making the most of the pot's pleasing rotundity.
British Museum.
(Courtesy Thames and Hudson Ltd)

In both these photographs an intentional use is made of the line dividing base from background.

Opposite:
Greek child's toy of the geometric period. Height 12½″. Taken with one 500 watt lamp with daylight. The viewpoint and the lighting angle were chosen to minimize the missing head and emphasize the several rotundities.
Courtesy Kerimachos Museum, Athens.

English Bow Porcelain Shepherdess. *c.* 1760. Taken with two 500 watt lamps almost evenly disposed, with a background of book-binding cloth. Four colour separation negatives were taken and a guide colour transparency. The advantage of this almost antiquated technique is that the transparency need not be totally sharp – it can be made at full aperture to achieve the standard exposure, and the four separation negatives are made with the lens stopped down.

Fitzwilliam Museum, Cambridge.

Venetian Glass Ewer. 18th century. 10″ high. Taken with two 500 watt lamps placed at unequal distances either side. A coloured felt base and background. Artificial light Ektachrome was used with a four second exposure.
Murano Museum of Glass, Venice.

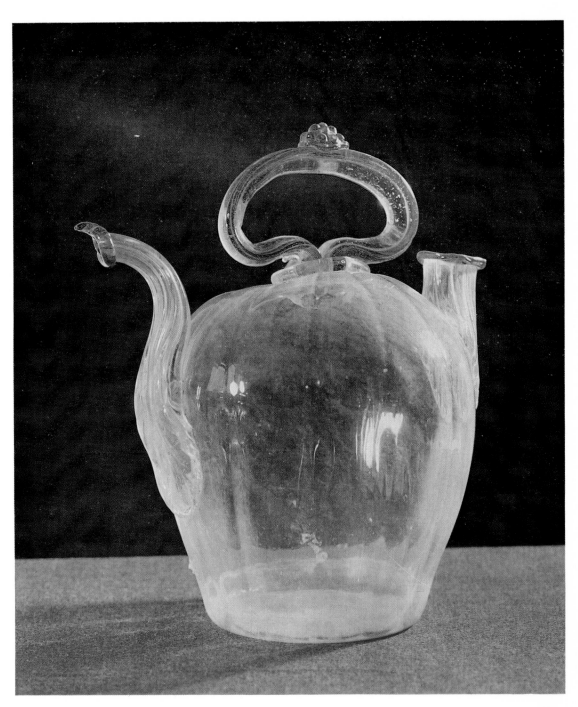

Bristol Delft charger: *c.* 1740. Decorated in earth colours and tin glazed. One 500 watt light with reflection from white wall. Shadow cast from left edge to relieve the white rim of charger. Light used to show surface quality.

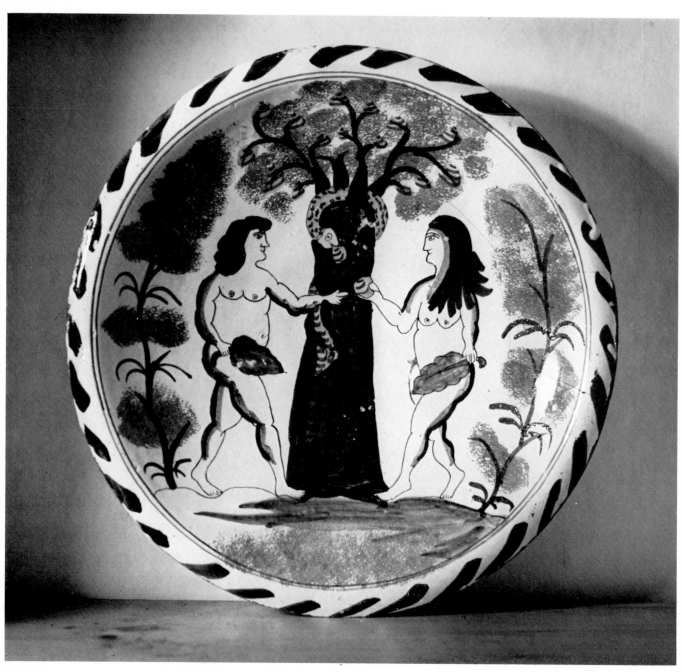

Pratt Jug: decorated in relief with underglazed colours, made in Staffordshire *c.* 1800. Photographed to reveal the relief modelling of the figure and the 'orange-peel' texture of the background. One 500 watt spotlight and one 500 watt fill-in light and with HP3 film, 5″ × 4″, at *f*.11 and ⅛th second.
Photograph Bob Alcock.

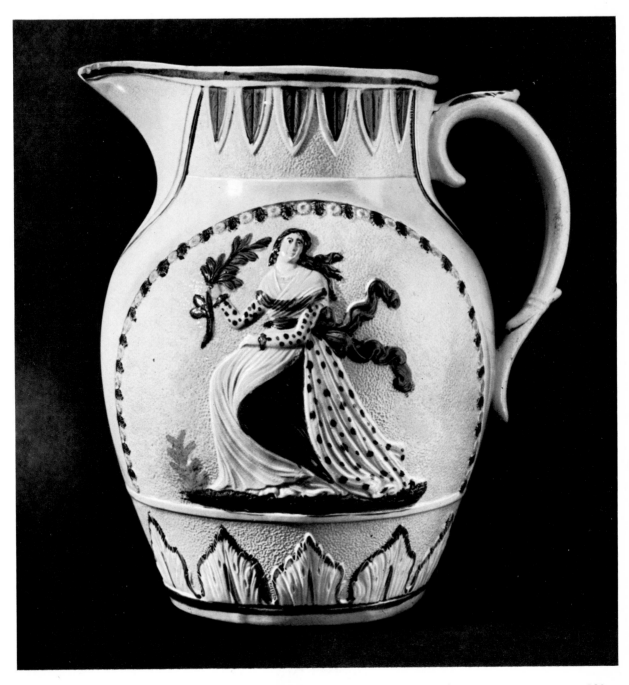

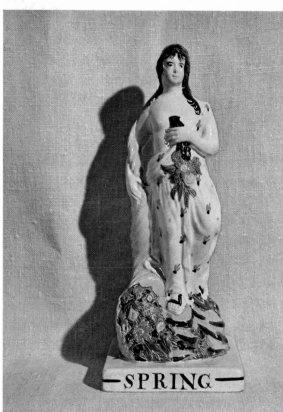

SPRING

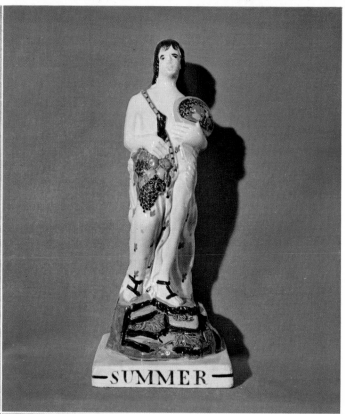

SUMMER

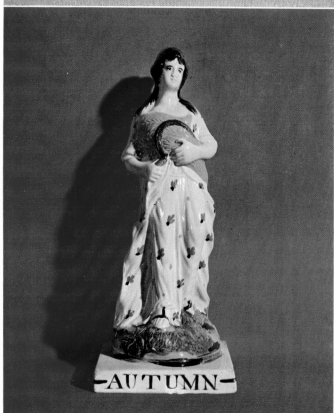

AUTUMN

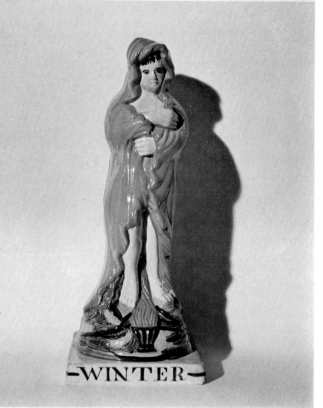

WINTER

BACKGROUNDS

Colour reproduction inevitably involves compromise. The same can be said about colour photography, for as we have written: 'Light and shade and full colour are ultimately incompatible, and no pictorial convention has succeeded in combining chiaroscuro and colour, with both working to full capacity.' This is where the compromise comes in. One either plays back the form or the colour. However, there are ways of getting round this difficulty. One of these is by the choice of colours for backgrounds. As an example of this, the four reproductions of the Sunderland Pottery Figures on the opposite page were photographed, in the case of *Spring*, *Summer* and *Autumn*, against strongly coloured backgrounds. *Spring* was photographed against a golden maize colour, to supplement the yellow on the cornucopia. *Summer* had a strong blue background both to indicate the blue sky of summer and to emphasize the blue in the grapes. *Autumn's* red was chosen mainly to be complementary to the other colours and like the maize and blue backgrounds, to be sufficiently dark tonally to throw the uncoloured pottery figure into silhouette. Conversely, the background for *Winter* (which incidentally, was white cartridge paper), was intended to throw the orange-cloaked figure into relief and also to suggest the coldness of winter. Ceramics are difficult subjects for photography either in colour or monochrome. The incidence of awkward highlights is a recurring problem.

We think that there is one final point worth making and that is, that when photographing for reproduction, the photographer should not fill the frame, but should allow considerable latitude for trim, both for 'bleeds' and for any difficulties of fitting a halftone reproduction to a layout.

Opposite:
Sunderland pottery figures representing 'The Seasons', *c*. 1820. Reproduced from four separate colour transparencies. The figures were photographed against three different pieces of coloured material and in the case of 'Winter' against white paper, under two 500 watt lamps. Type B Ektachrome 1/10th of a second at f.16.

Photographs Bob Alcock.

Appendix

Key-line drawings

A key drawing is made by placing a sheet of tracing paper on top of the original and then tracing in outline the different areas of colour and all other details. Where light colours come next to dark areas of colour, the darker colour should overlap very slightly, but when colours are of the same tone, great care should be taken that they abut exactly on the key line. It is essential that the key lines are drawn as very fine lines. For especially fine work, key drawings should be drawn with an etching needle on a sheet of gelatine. For lithographic work, key drawings should be made in lithographic ink on transfer tracing paper, or on a gelatine sheet (as above) then inked and wiped off with transfer ink. For letter-press work, or any other process, or if the drawings are to be reproduced to a different size the key should be drawn in Indian ink, so that it can be photographed.

The working key of the Toulouse-Lautrec poster opposite was produced for a line–letterpress reproduction. Also it actually provided the working drawing for the green printing. The solids on the men's jackets and the woman's hair and neck ribbon were overprinted in black. The fine lines in the background provided the key for the yellow printing and were cleared from the green plate before etching.

This key was not used for the four-colour half-tone silkscreen reproduction of this poster that appears in the book opposite page 80.

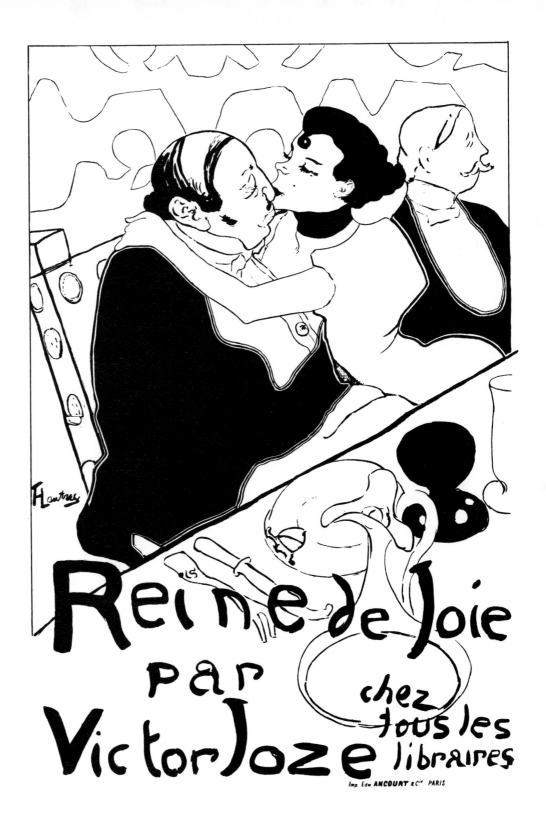

Key drawing for poster by H. de Toulouse-Lautrec

Production Details

This book has been set in Monotype 11/14 pt. Baskerville and printed by both offset litho and letterpress processes with separate inserts of gravure and silk-screen; and was planned and designed by John Lewis, F.S.I.A.

Paper for Litho	Evensyde white offset cartridge by John Dickinson & Co. Ltd. Fulmar coated cartridge by J. A. Weir Ltd.
Paper for Letterpress	Contemporary white art by Wiggins Teape Ltd.
Jacket paper	Tuffjack by Hale Paper Co. Ltd.
Endpapers	Metal Cover, gold shade by Spicer-Cowan Ltd.
Book cloth	Buckram shade 41 by Red Bridge Book Cloth Co. Ltd.
Four-colour Letterpress blocks	by Fine Art Engravers Ltd. Two subjects reproduced from separation negatives by Viaduct Process Block Co. Ltd.
Monochrome Letterpress blocks	by V. Siviter Smith Ltd. and by Viaduct Process Block Co. Ltd.
Silkscreen printing	by Display Craft Ltd.
Gravure printing	by D. H. Greaves Ltd.
Photo-litho reproduction letterpress and offset printing and binding	by W. S. Cowell Ltd at their press in the Butter Market, Ipswich, England.